David Präkel

# LIGHTING

*n*. light of a particular
quality or the equipment
that produces it.

ava Academia
the environment of learning

**An AVA Book**

Published by AVA Publishing SA
Rue des Fontenailles 16
Case Postale
1000 Lausanne 6
Switzerland
Tel: +41 786 005 109
Email: enquiries@avabooks.ch

Distributed by Thames & Hudson (ex-North America)
181a High Holborn
London WC1V 7QX
United Kingdom
Tel: +44 20 7845 5000
Fax: +44 20 7845 5055
Email: sales@thameshudson.co.uk
www.thamesandhudson.com

Distributed in the USA and Canada by:
Watson-Guptill Publications
770 Broadway
New York, New York 10003
Fax: +1 646 654 5487
Email: info@watsonguptill.com
www.watsonguptill.com

English Language Support Office
AVA Publishing (UK) Ltd.
Tel: +44 1903 204 455
Email: enquiries@avabooks.co.uk

ISBN 2-940373-03-5 and 978-2-940373-03-1

10 9 8 7 6 5 4 3 2 1

Illustrations by David Präkel
Design by Gavin Ambrose (gavinambrose.co.uk)
Cover image by Stéphane Bourson
Original book and series concept devised by Natalia Price-Cabrera

Production by AVA Book Production Pte. Ltd., Singapore
Tel: +65 6334 8173
Fax: +65 6259 9830
Email: production@avabooks.com.sg

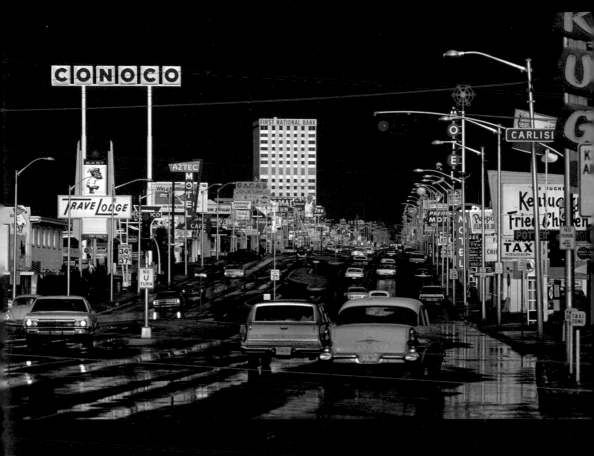

**Albuquerque, New Mexico, 1969**
After the rains, the photographer captures the brilliance of the sunlight against the dark distant clouds. Only sensitivity to the possibilities of light alerts a photographer to such a scene.

**Photographer:** Ernst Haas.

**Technical summary:** none supplied.

# Contents ▷

 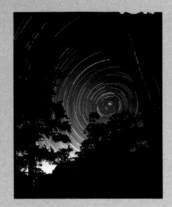 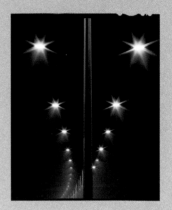

This book covers all forms of lighting and the equipment that produces it. Dedicated chapters explain the basic theory of light, natural light, light that is available and light that is specifically produced for photography. Later chapters look at how to control and use light, encouraging experimentation and exploration. The book is illustrated throughout with thought-provoking and creative images from contemporary practitioners, some of which have been taken especially for the book. Technical photographic concepts are identified, examined and explained in a straightforward manner.

**Main chapter pages**
These offer an introduction to the basic ideas that will be discussed.

**Headings**
Each important concept is shown in the heading at the top of the page, so that readers can refer quickly to a topic of interest.

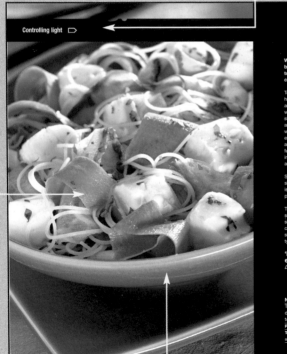

Controlling light ▷

110_111

Without light, there is no photography. Light in the natural environment can be controlled by the photographer but only to a small degree. Usually, that means waiting for the sun to move or for the weather to break. In the studio, however, the photographer has complete control over both the source(s) and the quality of light.

To have total control of light, the best studio to work in is a completely black-painted room that has no windows or that can be completely blacked-out. (Portrait photographers may disagree, as by choice they often prefer the natural light in a large, glass northlight studio, though they will be at the mercy of the weather and have only limited control of the light.) In a darkened studio, you can introduce lamps and reflectors with different qualities and position them anywhere within the three-dimensional space to create the lighting effect you want. Because we are so used to seeing the effect of natural light on objects, it is good to consider how those expectations will affect what we arrange in the studio. Low-angle light that looks like dusk or autumn may introduce an undesired effect. High overhead light may correctly show the features of the subject but could look too much like noon light, which might give an inappropriate message to the viewer. This can be especially important in commercial or advertising photography.

Studio lighting is not just a whim or fancy but is used to reveal – sometimes to conceal – line, shape, form, space, texture, light and colour. These are the formal elements of composition. It is best to have some understanding of what you are trying to achieve with lighting before ever putting a light on your subject.

The control we have over light in the studio concerns not only the direction and number of sources it comes from, but the quality of those sources. Quality is a combination of things, such as colour temperature (the blue to redness of the light) and the quality of the shadows it casts; whether it is a diffuse source that casts soft shadows or a point source that casts hard shadows. Colour temperature can be changed with gels or filters and by the selection of the type of lamp. The use of light shapers affects the shadows.

**'Light has to be understood before you can begin to control the end result in your photography.'**
*David Bailey (photographer)*

**Noodle Salad (facing opposite)**
The studio environment gives the photographer full control over light sources. Here the direction and quality of the lighting has been carefully judged to reveal the colours, form and textures of the food and tableware.
**Photographer:** Steve Payne.
**Technical summary:** Sinarback 54M (22Mpx) on 5x4 view camera with Sinar digital lens, exposure detail not supplied, ISO 50. Broncolor pack and heads.

**Introductory images**
Introductory images give a visual indication of the context for each chapter.

**Introductions**
Special section introductions outline basic concepts that will be discussed.

## Images

All images have been carefully chosen to demonstrate the theory or technique under discussion.

## Running glossary

Definitions run throughout the book delivering key information alongside the texts where extra explanation may be needed.

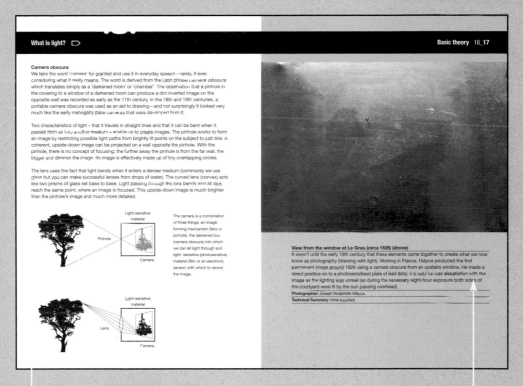

## Diagrams

Diagrams and charts are used to explain key technical concepts clearly and concisely.

## Image captions

Captions give creative and technical background to the image chosen and provide a summary of the camera, exposure details and lighting equipment used.

# Introduction ⟹

**Film or digital is not really the question. Light is the photographer's medium. The word 'photography' already embodies this idea, being derived from the Greek words for light and drawing. It is mastery of light that marks out the work of the truly great photographers.**

There are photographic moments where light is a 'given' and you have to make the best of what you have got. In other situations – in the studio, for instance – you are in full control of the lighting. Knowing the simple rules that light obeys and understanding something of its qualities and composition help a photographer work with light, rather than have it spoil their image with flare, lost highlights and shadow detail or colours that lack saturation.

Time of day may be critical to the landscape photographer's art as this determines not only the direction and angle of the light but also its colour quality. For a street photographer working with available light it becomes a matter of eking out what light is there. Other photographers will supplement natural light with flash whatever the weather. It is the studio photographer who has the greatest control, as every light and every shadow is his or her creation. What becomes important is to develop a photographer's eye for light – to see not just the subject but to see how the subject is lit.

## What is light?

For photographers to work successfully with light they need to understand its composition and the basic rules it follows. This section looks at colour theory, at how to measure light for correct exposure, how to filter light, and imaging at the ends of the visible spectrum.

## Natural light

Photographic daylight has a special meaning and is not what people presume. Natural light varies immensely in quality depending on the time of day, the season of the year and the location.

## Available light

This is light – not necessarily natural – that is around us all the time and available for making images. Available light photographers often work with low levels of light but capture some of the most evocative images.

## Photographic light

Light specifically generated for photographic use comes in continuous form, from tungsten or fluorescent lamps, for example, or as a high-energy flash. This section looks at the alternatives and their pros and cons.

## Controlling light

Studios can be thought of as an unlit box into which the photographer brings every light source and controls every reflection and shadow. Here we look at how simple lighting is adjusted and controlled and how complex lighting is built on first principles.

## Using light

Quality of light has a strong expressive component; this section looks at how a technical understanding can be used to fuel creativity. The section also looks at some ways of imaging without a camera.

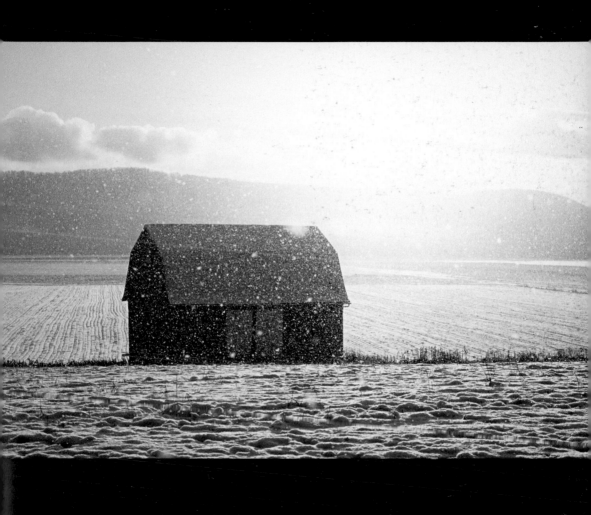

'...through this photographic eye you will be able to look out on a new light-world, a world for the most part uncharted and unexplored, a world that lies waiting to be discovered and revealed.'

*Edward Weston (photographer)*

**Barnstorm (above)**

One of the first pieces of advice that photographers are given is: 'Don't point the camera at the sun', but light itself can be the subject of a photograph.

**Photographer:** David Präkel.

**Technical summary:** Leica R8, 35–70mm Vario-Elmar-R, Ektachrome 100, exposure not recorded.

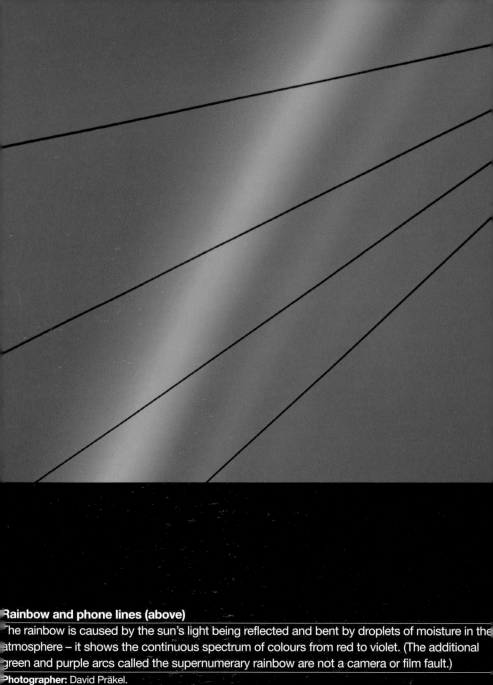

**Rainbow and phone lines (above)**

The rainbow is caused by the sun's light being reflected and bent by droplets of moisture in the atmosphere – it shows the continuous spectrum of colours from red to violet. (The additional green and purple arcs called the supernumerary rainbow are not a camera or film fault.)

**Photographer:** David Präkel.

**Technical summary:** Nikon D100, 70–300mm f4/5.6 AF-D at 130mm, 1/500 at f/5.6.

**Light is that narrow band of electromagnetic radiation to which the human eye is sensitive. There are no exact boundaries to the range of visible light, as individuals differ. Typically, our eyes are receptive to a range of wavelengths of light between 400–700 nanometres (nm). (A nanometre is one millionth of a millimetre.)**

There is radiant energy above and below the limits of the visible spectrum: above violet is described as ultraviolet, below red as infrared. Imaging systems (film and digital) can pick up these 'colours' and fold them back into visibility. We will look at colour and black-and-white infrared photography in some detail later in the book.

Light has three physical properties that interest the photographer – amplitude (or intensity), the wavelength or frequency and the angle of vibration (or polarization). In layman's terms, intensity can be thought of as the brightness of light and the frequency or wavelength determines its colour; we can barely perceive changes in polarization but this phenomenon can be manipulated photographically with polarizing filters. These are covered in a later section.

Light travels in straight lines, which is why we get shadows. It is also reflected off a mirror or silvered surface at the reverse angle to which it falls, like a billiard ball hitting a cushion. Knowledge of these simple facts allows photographers to shape light using cutters and reflectors. Light can also be bent (refracted), which means we can design lenses to focus images.

Without light, there are no colours. A green pepper only looks green if the corresponding wavelengths (colours) are present in the illuminating light. In orange light that contains no green, a green pepper will look grey and colourless.

We have a photographic definition of the light that contains all the colours and is therefore white – 'daylight' – but photographers use this term in a precise way and it is not quite what you may think. All our 'white' light comes from radiating energy sources – the sun, metal filaments heated by electric current (light bulbs), the light burst from an electric arc (flashgun). There is some implied connection with heat. Photographers use the idea of colour temperature – a spectrum derived from looking at the colours of objects as they heat up – to describe the precise colour of a light source, be it blue-white or yellow-white. Understanding colour temperature and how to control or adjust it is vital to film and digital camera work and the topic is discussed later.

## 'Light is our paint brush and it is a most willing tool in the hands of the one who studies it with sufficient care.'
*Laura Gilpin (American landscape photographer)*

# Basic theory

### Electromagnetic spectrum

We are familiar with the range of colours within the spectrum that exists between 400–700nm as the colours of the rainbow (red, orange, yellow, green, blue and violet – modern science no longer counts indigo as a usefully separate colour). The colours of the rainbow are what you see when a beam of light cuts through the edge of a drinking glass. This is exactly what happens in the controlled conditions of the physics laboratory using a prism of glass to create the coloured bands of the spectrum by bending (refracting) **white light**. The rainbow colours are spread out because different wavelengths (colours) of light move at different speeds through the denser glass. This simple observation is vital to accurate lens design as it is the source of colour fringes in images from less than perfect lenses. We need to understand the spectrum to know how to use **filters**.

### The Electromagnetic Spectrum

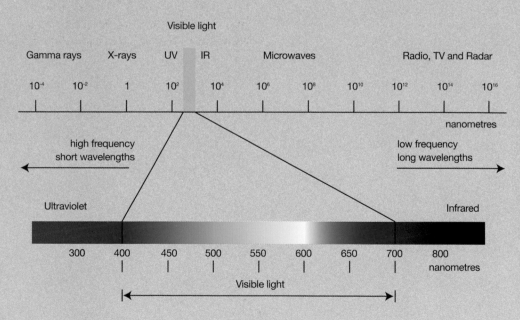

| | | | Visible light | | | | | | | |
| Gamma rays | X-rays | | UV | IR | Microwaves | | | | Radio, TV and Radar | |
| $10^{-4}$ | $10^{-2}$ | 1 | $10^{2}$ | $10^{4}$ | $10^{6}$ | $10^{8}$ | $10^{10}$ | $10^{12}$ | $10^{14}$ | $10^{16}$ |

nanometres

high frequency
short wavelengths

low frequency
long wavelengths

Ultraviolet

Infrared

| 300 | 400 | 450 | 500 | 550 | 600 | 650 | 700 | 800 |

nanometres

Visible light

### The inverse square law

The inverse square law states that the intensity of light observed from a constant source falls off as the square of the distance from the source.

Any light source that spreads its light in all directions obeys this law. In the real world, this is why it gets dark so quickly as you move away from the campfire!

Put simply, the inverse square law means that as you double the distance from the light you quarter the light intensity. In fact, the light falls off as 1 over (inverse) the distance multiplied by itself (squared). The light measured at 2 metres from a light source will be 1/22 or 1/4 the intensity at 1 metre. The light measured at 4 metres from the same source will be 1/42 or 1/16th the intensity at 1 metre.

Photographically speaking, as every stop means a halving or doubling of light, 1/4 the amount of light is 2 stops down; 1/16th of the light is 4 stops down. Therefore, a light meter reading f/16 at 1 metre, for example, would read f/8 at 2 metres and would read f/4 at 4 metres.

It is important to understand this law, as it is one of the main ways in which light intensity can be controlled in the studio. The only light source that does not obey this law is the sun – as any distance we move something on earth is trivial compared to the distance from the earth to the sun.

### Inverse square law

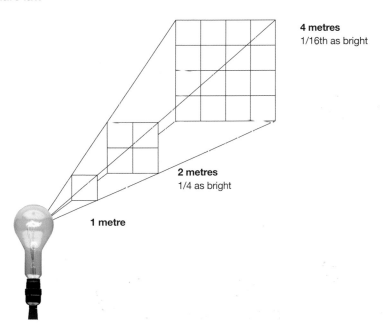

**4 metres**
1/16th as bright

**2 metres**
1/4 as bright

**1 metre**

## White light and primary colours

White light passing through a prism creates all the colours of the rainbow, but only three of these colours are necessary to make up all the others. These are called the additive primary colours – red, green and blue – familiar from the 'RGB' label used in TV, computer monitor and video 'speak'. Add equal quantities of red, green and blue light to make white.

**Additive colour mixing**

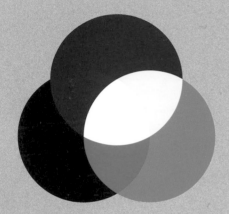

**Subtractive colour mixing**

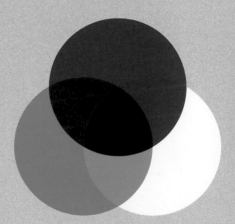

Subtract any one of these colours – red, green or blue – from white light and you are left with a combination of the remaining primaries. The colours from the remaining combinations – cyan, magenta and yellow – are the so-called subtractive primaries. RGB is the additive world of light and of the digital sensor; CMY is the world of reflected light, where these colours are used as dyes or pigments in our inks on white paper or as chemical dyes in film, to act as filters on white light to create the range of visible colours. Add equal quantities of cyan, magenta and yellow inks and you get black.*

* True black is added in four-colour (CMYK) printing, as real-world ink pigments are not pure enough to give black, instead giving a dirty purple-brown.

Photographers find it useful to put the colours of the spectrum on a wheel, which helps in understanding how to filter and manipulate light. Red, green and blue will be found 120° apart on the wheel (at the 12 o'clock, 4 o'clock and 8 o'clock positions). All other colours as combinations of the three primaries lie in between. In colour correction, you use opposite colours on the wheel to cancel each other out. For instance, an image with a particular blue cast can be corrected by adding the yellow that lies opposite that blue on the colour wheel. The black-and-white photographer, wanting to darken the sky's appearance, would choose a red filter opposite to the sky's colour (cyan) on the wheel.

Digital camera users will often find hue (colour) adjustments described as a certain number of degrees. This represents a shift in colour around the colour wheel through an arc of that angle, rather like moving a few minutes round a clock face.

Adjustments to colour images in computer software make sense when you understand the colour wheel. Imagine a strip taken from round the edge of the wheel being used to show every possible colour – it would start and end at the same place (cyan, in the case of the Photoshop sliders).

**The colour wheel**

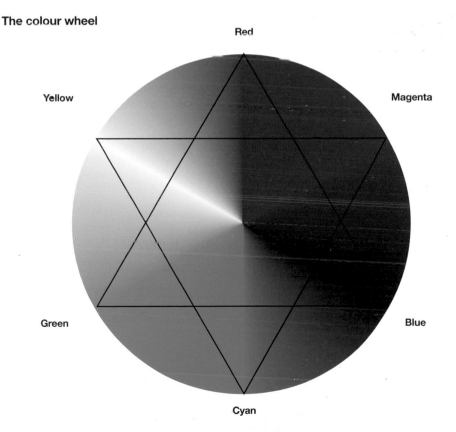

Red

Yellow

Magenta

Green

Blue

Cyan

## Camera obscura

We take the word 'camera' for granted and use it in everyday speech – rarely, if ever, considering what it really means. The word is derived from the Latin phrase *camera obscura*, which translates simply as a 'darkened room' or 'chamber'. The observation that a pinhole in the covering to a window of a darkened room can produce a dim inverted image on the opposite wall was recorded as early as the 11th century. In the 18th and 19th centuries, a portable camera obscura was used as an aid to drawing – and not surprisingly it looked very much like the early mahogany plate cameras that were developed from it.

Two characteristics of light – that it travels in straight lines and that it can be bent when it passes from air into another medium – enable us to create images. The pinhole works to form an image by restricting possible light paths from brightly lit points on the subject to just one. A coherent, upside-down image can be projected on a wall opposite the pinhole. With the pinhole, there is no concept of focusing; the further away the pinhole is from the far wall, the bigger and dimmer the image. Its image is effectively made up of tiny overlapping circles.

The lens uses the fact that light bends when it enters a denser medium (commonly we use glass but you can make successful lenses from drops of water). The curved lens (convex) acts like two prisms of glass set base to base. Light passing through the lens bends and all rays reach the same point, where an image is focused. This upside-down image is much brighter than the pinhole's image and much more detailed.

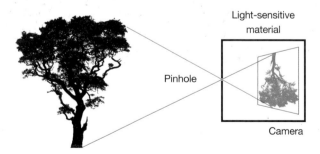

Light-sensitive material

Pinhole

Camera

The camera is a combination of three things: an image-forming mechanism (lens or pinhole), the darkened box (camera obscura) into which we can let light through and light- sensitive (photosensitive) material (film or an electronic sensor) with which to record the image.

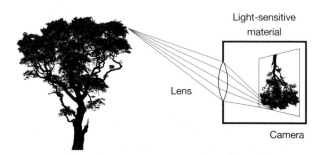

Light-sensitive material

Lens

Camera

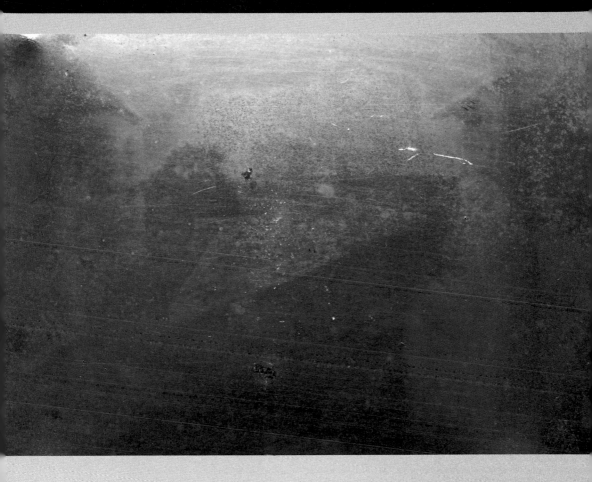

**View from the window at Le Gras (circa 1826) (above)**

It wasn't until the early 19th century that these elements came together to create what we now know as photography (drawing with light). Working in France, Niépce produced the first permanent image around 1826 using a camera obscura from an upstairs window. He made a direct positive on to a photosensitized plate of lead alloy. It is said he was dissatisfied with the image as the lighting was unreal (as during the necessary eight-hour exposure both sides of the courtyard were lit by the sun passing overhead).

**Photographer:** Joseph Nicéphore Niépce.

**Technical Summary**: none supplied.

## Pinholes and the simple lens

Both image-forming techniques are available to the photographer today. In fact, a move against the sophistication of the modern lens has lead to the re-introduction of simple lenses in flexible mounts. These can be fitted to modern camera bodies enabling photographers to re-discover limited depth-of-field, 'un-sharpness', everywhere but at the image centre and colour fringing.

Modern pinholes can be purchased either pre-cut or made experimentally by the photographer using a pin or small drill and a sheet of thin metal or plastics. Some companies will supply camera body caps with precision-cut pinholes that permit easy pinhole photography both digitally and on modern films. Some workers prefer to make their own cameras and they use either large sheet film for later contact printing or use photographic paper as a paper negative. This material is much slower to react to light and provides opportunities for even longer time exposures.

Modern lens design has, to some degree, sanitized our images. Lenses now show only residual distortions. Consequently, many photographers seek out the qualities of older lenses for their evocative image making. Simple lenses do not have edge-to-edge sharpness, often showing light fall-off in the corners of the image (vignetting). Nor do they focus all colours of the spectrum at the same point (chromatic aberration), which leads to colour fringed images. Older lenses are often described as 'soft', as they may not have either the contrast or sharpness of a modern lens. It is precisely these 'poor' qualities that make them interesting to some photographers.

For a while in the fashion industry, images taken on cheap 'toy' cameras like the Diana and Holga – with their crude plastics lenses and rarely light-tight camera bodies – were all the rage. In fact, the Holga camera, now made in China, still has a cult following for the simplicity of its operation and images.

One manufacturer has enshrined these qualities with the convenience of mounting on modern camera bodies. The Lensbaby is a simple lens set in a flexible tube mount that can be attached to any modern SLR camera, digital or film. Focusing, such as it is, is done by pulling and pushing the mount in and out. This also allows the lens to be swung on its axis, thereby shifting the plane of focus relative to the camera back – something not usually possible with modern digital and 35mm cameras. The creative possibilities are immense and the distinctive lack of modern 'quality' from such lenses has been a great attraction in the worlds of fine art, fashion and advertising.

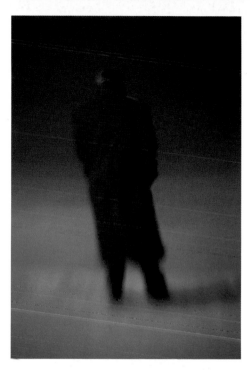

### Nothing is certain (left)

A simple lens can create an atmospherically charged image.

**Photographer:** Lisa Smith.

**Technical summary:** Canon D60, Lensbaby Original, 1 sec (handheld), ISO 1000, street lighting. Slight saturation and contrast boost in RAW file conversion.

### Royal Crescent, Bath (below)

Classic pinhole image shows wide angle of view, light fall off at the image edges and everything in focus – albeit softly. Buildings in background are curved, this is not image distortion.

**Photographer:** Justin Quinnell.

**Technical summary:** 126 Kodacolor 200 film image 26mm square, homemade 126 cartridge camera, 5 sec with an effective aperture of f/105 in ambient sunlight.

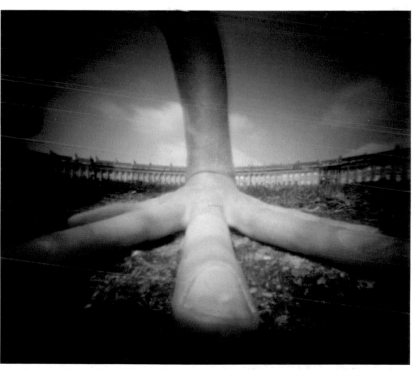

# Colour theory

### Colour temperature

Phrases like 'red hot' and 'white hot' are in everyday use. In the first Industrial Revolution of the late 18th and early 19th centuries, it became important to judge accurately the temperature of industrial processes such as smelting and glass-making. Traditionally, this was done by observing the colour of the furnace. William Thompson, the 19th-century physicist and later Lord Kelvin, formalised these observations and the unit of **colour temperature**, kelvin (not degrees kelvin), is named after him.

If a dull block of iron is heated to white-hot, it passes through the full range of colours from dull red through yellow. The colour temperature scale relates directly to this idea of the colour change seen when heating an object. Kelvin took the actual temperature and added the value of absolute zero to create his scale. The block of iron analogy runs out at 'white-hot', as in the air this is where the iron would begin to burn (oxidize). Exclude the air by putting the block in a vacuum; keep pumping in more energy and the colour will change from white to blue (we have just invented the light bulb).

### Colour temperature

| Colour | Description | Actual temperature | | Colour temperature (kelvin) |
|---|---|---|---|---|
| | Extremely dull red | 480°C | | 753K |
| | Very dark red | 630°C | | 903K |
| | Dark red | 750°C | Absolute zero | 1023K |
| | Cherry red | 815°C | +273 | 1088K |
| | Light cherry red | 900°C | | 1173K |
| | Orange red | 990°C | | 1263K |
| | Yellow | 1150°C | | 1423K |
| | Yellow-white | 1330°C | | 1603K |

### Colour temperature of common light sources

| | |
|---|---|
| Candles and oil lamps | 2000K |
| Household light bulbs | 2900K |
| Sunrise or sunset lighting | 3100K |
| Studio tungsten | 3200K |
| Photoflood lamps (overrun) | 3400K |
| Morning/evening sunshine | 3800K |
| Noon daylight/electronic flash | 5500K |
| Overcast sky | 7000K |
| Clear blue sky | 10000K |
| Reflections from clear blue sky in shade | 16000K |

The sun is a source of radiant energy. Many of our light sources are incandescent (glowing) sources, usually created by heating a metal filament in a vacuum. In colour photography, we need to take into account the quality (temperature) of the illuminating light. Time of day has a big effect on the colour of light. To be able to photograph in a range of lighting conditions, yet keep white appearing as white and not blue-white or yellow-white, we need to be able to either filter the light source or use an appropriate film stock for that light. Digital cameras too can be adjusted to give neutral whites across a range of light sources with varying colour temperatures.

**colour temperature** measure of 'whiteness' of light, measured in kelvin

Working out which filter will convert the colour of one light source to another is done using a nomograph. Simply draw a line connecting the colour temperature of the original light source with the converted source. The necessary **mired** shift to achieve the change can be read off from the centre scale. The filters that produce the necessary shift are also shown. This nomograph shows only photographic filters for use on the camera; you will find other charts that additionally show the coloured gels that can be used on the light sources themselves, a practice more common in the film and TV industries.

## A nomograph

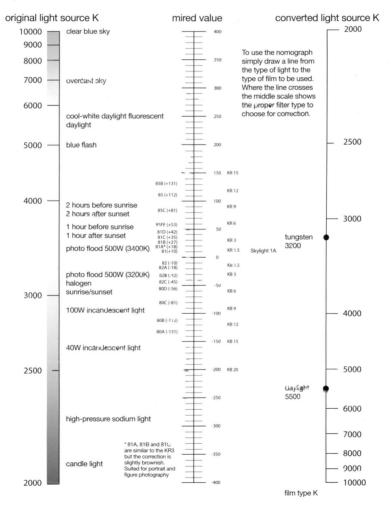

original light source K

| | |
|---|---|
| 10000 | clear blue sky |
| 9000 | |
| 8000 | |
| 7000 | overcast sky |
| 6000 | |
| 5000 | cool-white daylight fluorescent daylight |
| | blue flash |
| 4000 | 2 hours before sunrise / 2 hours after sunset |
| | 1 hour before sunrise / 1 hour after sunset |
| | photo flood 500W (3400K) |
| | photo flood 500W (3200K) / halogen / sunrise/sunset |
| 3000 | 100W incandescent light |
| | 40W incandescent light |
| 2500 | high-pressure sodium light |
| | candle light |
| 2000 | |

mired value

| | |
|---|---|
| 400 | |
| 350 | |
| 300 | |
| 250 | |
| 200 | |
| 150 | KR 15 |
| | KR 12 |
| 100 | KR 9 |
| | KR 6 |
| 50 | KR 3 |
| | KR 1.5 |
| 0 | |
| | KB 1.5 |
| | KB 3 |
| -50 | KB 6 |
| | KB 9 |
| -100 | KB 12 |
| -150 | KB 15 |
| -200 | KB 20 |
| -250 | |
| -300 | |
| -350 | |
| -400 | |

85B (+131)
85 (+112)
85C (+81)
85FF (+53)
81D (+42)
81C (+35)
81B (+27)
81A* (+18)
81(+10)
82 (-10)
82A (-18)
82B (-32)
82C (-45)
80D (-56)
80C (-81)
80B (-112)
80A (-131)

To use the nomograph simply draw a line from the type of light to the type of film to be used. Where the line crosses the middle scale shows the proper filter type to choose for correction.

Skylight 1A

tungsten 3200

converted light source K

| | |
|---|---|
| 2000 | |
| 2500 | |
| 3000 | |
| 4000 | |
| 5000 | |
| 6000 | |
| 7000 | |
| 8000 | |
| 9000 | |
| 10000 | |

Daylight 5500

film type K

* 81A, 81B and 81C are similar to the KR3 but the correction is slightly brownish. Suited for portrait and figure photography

**mired** from **mi**cro **re**ciprocal **d**egrees – pronounced 'my-red'. One million divided by colour temperature; commonly used unit when converting from one colour temperature to another using filters – also mired shift (Expression reciprocal mega kelvin beginning to be used.)

## Colour balance

The human eye and brain will adjust our perception of white whatever the colour quality of the illuminating light source. Digital cameras make something like this adjustment when switched into automatic white balance (AWB). With colour film, if adjustment is needed to avoid a **colour cast** – and it usually will need at least fine-tuning – then a filter has to be used.

Colour films are balanced to give neutral results with very specific colour temperatures. Daylight film (see pages 58-9 for a description of photographic daylight) is balanced for a colour temperature of 5500K. Tungsten film is balanced for a temperature of 3200K. (Older technical books refer to two types of tungsten film – Type A balanced for 3400K and Type B at 3200K.)

By the correct use of conversion filters, daylight film can be balanced for use with artificial lights or artificial light film (tungsten) balanced for daylight use. These are the extreme cases; more likely is the subtle adjustment necessary of film to a light source that is close to, but not precisely at, the film's specified colour temperature.

**Colour conversion filters** let the photographer match the colour temperature of the lighting to the film in use. They can also be used to modify the **colour balance**. In Europe, the filters are described as KB (bluish) filters, which increase colour temperature, or KR (reddish) filters, which reduce it.

There is an older system of describing filters called the Wratten numbering scheme. This was named after Frederick Wratten who sold his coloured filter company to Eastman Kodak at the beginning of the 20th century. Wratten numbers can seem confusing but are still used in both the USA and the UK today.

The Wratten colour conversion filters in the deep blue 80 series and deep orange 85 series are used for making major shifts in colour temperature. The Wratten 81 series filters (yellow-amber) lower the colour temperature and 82 series filters (light blue) raise the colour temperature over a range of several hundred degrees. They are referred to as **colour balancing** or **light balancing filters**. These raise or lower colour temperature in much smaller steps than the colour conversion filters.

**colour balance** truthfulness of colours across the spectrum

**colour balancing (light balancing) filters** amber and blue filters used when making colour temperature changes, sometimes referred to as warming or cooling filters respectively or light balancing filters

**colour cast** unwanted, overall colour change in an image

**colour conversion filters** deep blue and orange filters used to achieve significant shifts in colour temperature, and to correct white balance when using film and lighting of a different target colour temperature

**filter factor** filters cut out certain wavelengths of light, reducing the total amount of light that reaches the film or sensor – for a correct exposure an allowance must be made. A filter that cuts out half the light will have a factor of x2 and one stop must be added to the exposure indicated by an incident light meter reading. On the whole TTL meters in cameras are not affected

## Matching colour film to light source

| Colour | Balanced for | Filter required | | |
|---|---|---|---|---|
| | | Daylight (or electronic flash) | Photo lamp (3400K) | Tungsten (3200K) |
| Daylight | Daylight, or electronic flash (5500K) | None | 80B/KB 12 | 80A/KB 15 |
| Tungsten | (3200K) | 85B/KR 15 | 81A | None |

## Filters

| Europe | Wratten | Colour | Effect |
|---|---|---|---|
| KR 1.5 | Skylight 1A | light salmon pink | Reduces bluish cast in scenic shots and snow scenes or pictures taken around noon. Absorbs UV, commonly used to protect the lens. No light loss. |
| KR 3 | | slightly darker salmon pink | Stronger effect than the Skylight filter, especially useful for hazy sunlight, cloudy overcast days and at higher elevations. Useful with Kodachrome to avoid blue haze. |
| | 81A 81B 81C | slight brown | Similar to KR 3 but browner. Especially suited for portrait and figure photography where skin tones are more pleasingly reproduced. Each creates a 100K shift in colour correction. |
| KR 6 | 81E 81F | medium reddish | For daylight colour film shot in deep shadows with sunny illumination or for architectural interiors (churches) on cloudy days. |
| KR 9 | | reddish | More effective than KR 6. For heavy daylight shadows and underwater photography. |
| KR 12 | 85 | reddish-brown | Converts tungsten-balanced transparency film (old Type A 3400K) to daylight (5500K). |
| KR 15 | 85B | red-brown | Reduces colour temperature by 2300K to balance tungsten film 3200K to daylight. **Filter factor** x2. |
| KB 1.5 | 82A | slightly blue | Removes reddish-yellow cast during morning and evening light. It increases the colour temperature by 200K. |
| KB 3 | 82B | bluish | Stronger effect than the KB 1.5 and corrects the red cast from tungsten illumination when using Tungsten film. |
| KB 6 | 82C | medium violet blue | Increases colour temperature by 1400K. Clears strong red cast from early morning and evening light. Often used for theatre and stage photography. Increases colour temperature by 1700K and has a stronger effect than KB 3. |
| KB 9 | 80C | blue | Increases colour temperature by 1700K and has a stronger effect than KB 6. |
| KB 12 | 80B | blue | Converts daylight slide film to use with 3400K lighting (photofloods or halogen lamps). Filter factor x3. |
| KB 15 | 80A | blue | Use with daylight film under 3200K tungsten lamps (60W and 100W). Filter factor x4. |
| KB 20 | | deep blue | Increases colour temperature by 2700K; used with candlelight. Used in the movie industry to film night-time scenes during daylight. Filter factor x5. |

## Colour correction

Colour correction or **colour compensating (CC) filters** have traditionally been used to make changes in the overall colour balance of images or to correct colour casts. They can also be used to correct manufacturing batch variations in colour film, slight deficiencies in studio lighting or reciprocity effects with film. More commonly today, subtle shifts in colour are made after scanning or capture using colour editing software.

CC filters are usually found as gels (not glass) and are available in cyan, magenta, yellow, red, green and blue in a range of densities rated 05, and 10–50 in units of ten. Intermediate values can be made by stacking filters together. The red filters are still commonly used in underwater photography to re-balance colour.

### Colour correction filters – exposure increase in stops

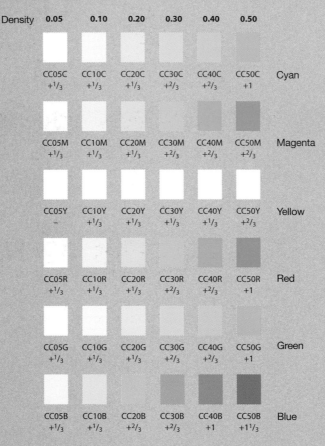

| Density | 0.05 | 0.10 | 0.20 | 0.30 | 0.40 | 0.50 | |
|---|---|---|---|---|---|---|---|
| | CC05C $+1/3$ | CC10C $+1/3$ | CC20C $+1/3$ | CC30C $+2/3$ | CC40C $+2/3$ | CC50C $+1$ | Cyan |
| | CC05M $+1/3$ | CC10M $+1/3$ | CC20M $+1/3$ | CC30M $+2/3$ | CC40M $+2/3$ | CC50M $+2/3$ | Magenta |
| | CC05Y $-$ | CC10Y $+1/3$ | CC20Y $+1/3$ | CC30Y $+1/3$ | CC40Y $+1/3$ | CC50Y $+2/3$ | Yellow |
| | CC05R $+1/3$ | CC10R $+1/3$ | CC20R $+1/3$ | CC30R $+2/3$ | CC40R $+2/3$ | CC50R $+1$ | Red |
| | CC05G $+1/3$ | CC10G $+1/3$ | CC20G $+1/3$ | CC30G $+2/3$ | CC40G $+2/3$ | CC50G $+1$ | Green |
| | CC05B $+1/3$ | CC10B $+1/3$ | CC20B $+2/3$ | CC30B $+2/3$ | CC40B $+1$ | CC50B $+11/3$ | Blue |

## Warming and cooling filters

Though technically the Wratten 81 series filters warm up and the 82 series cooling filters are designed to rebalance film white point accurately, they are more commonly used for aesthetic purposes. The fashion photographer Terence Donovan once pointed out that a client never criticised an image as being too warm.

### Kirkhaugh, Northumberland (below)

Comparison of the effects of 81 series warming and 82 series cooling filters.

**Photographer:** David Präkel.

**Technical summary:** Nikon D100, 18–35 AF-D f3.5/4.5 at 35mm, 1/500 at f/11 (no filter) **ISO** 200.

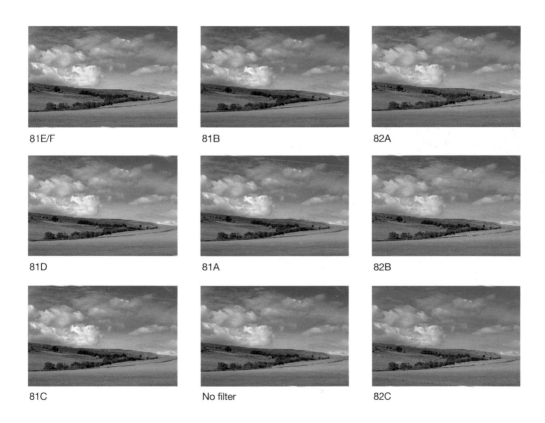

81E/F

81B

82A

81D

81A

82B

81C

No filter

82C

## White balance

The human eye and brain keep 'white' the things we know are white, whatever the colour quality of the lights we are under. To our eyes, the white paper of the pages of a book are white whether we are reading them by daylight or under tungsten or tungsten halogen lights indoors.

Digital cameras represent colours as a combined level of red, green and blue light. The highest numbers they record are 255 in an 8-bit file, so R255, G255, B255 represents white light, just as R0, G0, B0 represents no light – black in other words. It follows that as long as the RGB numbers are the same, some level of grey will be represented. Effectively, what the digital camera does to achieve automatic white balance (AWB) is to look for pixels where the RGB numbers are very close. Those pixels are then 'corrected' by evening up the numbers and making the colour a neutral shade of grey. That numerical shift applied to all the other colours in the image should effect a correct **white balance**.

In many instances – especially where mixed colour temperature light sources are present – automatic white balance does a good job of achieving acceptable results. Alternatively, the camera user can override the automatic setting by choosing a preset colour temperature value from Daylight, Tungsten, and usually a range of Fluorescent settings. Some cameras offer colour temperature choice in kelvin.

The best option of all is to use the camera to measure the white balance from a neutral reference. The custom white balance feature is useful where difficult colour temperature conditions occur – a daylight and fluorescent mix, for example. An image of a white or **grey card** is captured under the light and that is designated as neutral; the camera then assigns a specific colour balance for those lighting conditions. Some advanced professional digital cameras have built-in meters and can achieve a correct white balance at the press of a single button.

Not only does the Camera RAW (12-bit) digital file format have the capability of recording a range of possible exposures in one file but it also gives after-the-fact adjustment of colour temperature across a wide range. Though it is best to get white balance sorted at the time of exposure, the RAW format will allow the production of a wide range of colour temperature instances from the single file. This can be achieved by choosing a colour temperature from a pick list (Daylight, Cloudy, Shade…) and fine-tuning that value. Alternatively, the computer can calculate a value as described above, or you can use a grey eyedropper to sample a colour in the image that should be neutral and have the computer use that as its white balance target.

The temptation to over-correct white balance should be resisted. We are happy to accept some yellow in the images of light from candles or oil lamps. At the other end of the colour temperature spectrum, we expect reflected light from snow to be a little blue. Over-correcting snow and candlelight images for technically perfect whites creates an oddly sterile look.

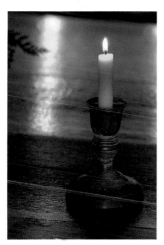 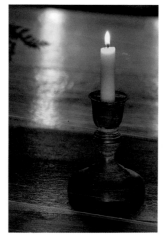 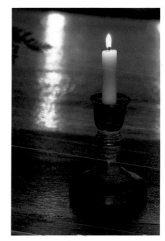

As shot                    Tungsten balance                    Over-corrected

### By candlelight (above)

Left: As shot, the camera produces a warm yellow image from the mix of candlelight and tungsten halogen light reflected from the table surface.

Centre: Tungsten balance (which in this instance is the same colour temperature you get by asking the computer to automatically calculate a value) shows the reflected light as pure white and leaves the candle light with some yellow colouration.

Right: Correcting for the candle light alone produces an overall blue cast elsewhere, isolating the candle and its flame. The image is technically correct but the overall effect is absurd.

**Photographer:** David Präkel.

**Technical summary:** Nikon D100 70–300mm f/4–5.6 AF-D zoom at 190mm, 1/4 sec at f/4.8, White Balance Auto.

**grey card** standard piece of card that reflects 18% of the light falling on it to provide an exact mid-tone light reading

**white balance** adjusting for the colour temperature of the illuminating light, so white and neutral colours appear truly neutral and do not have a colour cast

## Using a colour checker

When technically correct colour is important it helps to use a known colour reference. Called colour checkers or colour separation guides they can vary in both price and quality, but any is better than none. The best known is the Gretag-Macbeth Colour Checker chart.

Once a shot has been set up it is first captured with the colour checker in place. The chart should be positioned so as not to reflect light back into the camera; it needs to be roughly square on and large enough in the frame. A second exposure is then taken with the colour checker removed. This will be the image used for the client or publication. The lighting must be the same for both exposures.

Colour corrections and level adjustments can now be made with image editing software using the chart as a reference, and the values of these changes recorded. These values are then applied to the second image, effecting a colour correction to the image for use based on the first image that contained the colour chart.

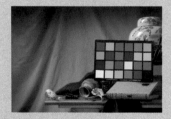 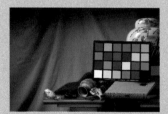 

**Allegory on the vanities of human life**
**(after Harmen Steenwyck, Dutch 17th-century painter)**
Left: Still-life image as shot with colour checker in place.
Centre: Image corrected for colour, brightness and contrast on computer.
Right: Recorded changes made to final image for client.
**Photographer:** David Präkel.
**Technical summary:** Nikon D100 60mm Micro-Nikkor AF-D, 1/4 at f/11, mixed daylight and tungsten (on backdrop).

## Filters for black-and-white photography

In black-and-white photography, filters are used to control the grey tones in which the various colours reproduce. Without filters some colours will reproduce only weakly. Certain shades of red and green, for example, reproduce as close grey tones in a black-and-white print and can only be differentiated by the use of coloured filters. Skies can often appear overexposed and white, as film is naturally sensitive to blue light. Filters are also used to control the contrast in black-and-white images.

To understand the action of a photographic filter you need to know that filters pass light of their own colour but block the other colours in the spectrum. A red filter will block out much of the blue and green light from a scene, so blue and green coloured subjects will reproduce darker than the red light, which passes through. A red filter can therefore be used to darken blue skies. The general rules in using filters with black-and-white film are: to darken a colour, use a filter of the complementary colour (opposite on the colour wheel); to lighten a colour, use a filter of the same or similar colour.

Many filters still have descriptive names and some photographers will refer to 'sky filters', for instance, as the collective name for yellow, orange or red filters, all of which act to darken the blue to cyan colours of the sky.

It is also important to remember that because filters cut down the amount of light reaching the film, some compensation has to be made by increasing the exposure. This varies depending on the filter and the manufacturer will give a filter factor that is commonly engraved on the filter mount, in the case of a screw-in glass filter.

Although you can easily see the effect of the filter through your SLR camera lens, it is not always safe to rely on the meter reading. Some camera meters are only accurate when measuring a mixture of all wavelengths and not filtered light. It is safest to take a reading without the filter, fit the filter and increase the exposure as suggested in the table opposite or according to the filter manufacturer's recommendations.

## Effect of filters

Colour original scene

Black-and-white

Deep Red Wratten 29

Red Wratten 25

Orange Wratten 22

Yellow Wratten 12

Green YG

| Filter description | Wratten number | Use | Exposure increase |
|---|---|---|---|
| Medium yellow | 8 | Darkens blue skies a little to make clouds more visible. Leaves are slightly lighter. Reduces haze. Crisps snow. | 1–1½ stops |
| Yellow-green | 11 | Corrects black-and-white film sensitivity for tungsten lighting. A 'spring and summer' filter that lightens leaves. Lightens white skin to natural appearance. | 1½ stops |
| Deep yellow | 12 | Can be thought of as a 'minus blue' filter that darkens blue skies. | 1½–2 stops |
| Dark yellow | 15 | Darkens blue skies to increase cloud reproduction. | 2 stops |
| Yellow-orange | 16 | Has more effect on skies than a yellow filter. Used in portraiture to reduce effect of skin blemishes. | 1⅔ stops |
| Orange | 22 | Greater effect on skies than yellow-orange, especially at sunrise and sunset. Lightens brickwork and darkens leaves. Smooths skin tone. | 2 stops |
| Red | 25 | Dramatically darkens blue skies, deepens shadows and enhances contrast. | 3 stops |
| Dark red/strong red | 29 | Even stronger effect than red. Can be used with telephoto lenses to darken sky close to a distant horizon. | 4 stops |
| Magenta | 32 | Can be thought of as a 'minus green' filter that darkens greens. | 1⅔ stops |
| Light blue-green | 44 | Can be thought of as a 'minus red' filter that darkens reds. | 2½ stops |
| Deep blue | 47 | Emphasises haze to increase aerial perspective in landscapes. | 2⅓ stops |
| Deep green | 58 | Lightens foliage. | 3 stops |

| Filter factor | f-stop | Filter factor | f-stop | Filter factor | f-stop |
|---|---|---|---|---|---|
| x1 | – | x3.2 | 1⅔ | x10 | 3⅓ |
| x1.2 | ¼ | x3.4 | 1¾ | x11.4 | 3½ |
| x1.25 | ⅓ | x4 | 2 | x12.6 | 3⅔ |
| x1.4 | ½ | x4.8 | 2¼ | x13.5 | 3¾ |
| x1.6 | ⅔ | x5 | 2⅓ | x16 | 4 |
| x1.7 | ¾ | x5.7 | 2½ | x32 | 5 |
| x2 | 1 | x6.4 | 2⅔ | x64 | 6 |
| x2.4 | 1¼ | x6.8 | 2¾ | x1000 | 10 |
| x2.5 | 1⅓ | x8 | 3 | x10 000 | 13 |
| x2.8 | 1½ | x9.5 | 3¼ | x1million | 20 |

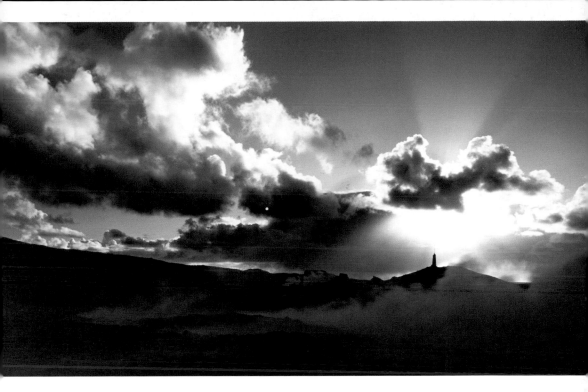

### Lighthouse, Iceland

A red filter darkens blue skies and adds drama and modelling to the clouds which now stand out against the darker sky. Spectacular effects can be achieved by combining a red filter with a polarizer.

**Photographer:** Michael Trevillion, Trevillion Images.

**Technical summary:** Pentax 67, SMC Pentax 55mm, 1/2 sec at f/16 with red filter. No Photoshop.

**f-stop** diameter of the lens opening represented as a fraction of the focal length. The bigger the f number, the smaller the opening

# Exposure

## Exposure value
**Exposure Value (EV) numbers** are a way to describe exposure settings with just a single number, instead of the usual f-stop and shutter speed combinations. A single number represents all combinations of apertures and shutter speeds that give the same exposure. For example, EV10 in the table can represent any combination of aperture and shutter speed from 4 sec at f/64 to 1/1000 sec at f/1.

Professional standard **light (exposure) meters** commonly have a display of the measured light in EV numbers in addition to the f-stops and shutter speeds. The EV unit is one stop. Many professional photographers prefer to think in terms of exposure values as it helps them deal with the light and not the camera settings. For any given amount of light, there are many ways in which the camera settings of aperture and shutter speed can be combined to produce a correct exposure in accordance with the law of reciprocity. This states that an increase in light intensity must be matched by a corresponding decrease in the duration of the light to achieve a correct exposure. It was once common for amateur mid-20th century cameras to be set using a single EV number, now only certain professional camera lenses retain this convenience. The EV number is transferred from the light meter to the lens, which locks the shutter speeds and apertures in the appropriate relationship, from which a suitable pair can then be chosen.

## Table of exposure values (ISO 100)

| shutter (s) | 1 | 1.4 | 2 | 2.8 | 4 | 5.6 | 8 | 11 | 16 | 22 | 32 | 45 | 64 |
|---|---|---|---|---|---|---|---|---|---|---|---|---|---|
| | | | | | | f-number | | | | | | | |
| 60 | -6 | -5 | -4 | -3 | -2 | -1 | 0 | 1 | 2 | 3 | 4 | 5 | 6 |
| 30 | -5 | -4 | -3 | -2 | -1 | 0 | 1 | 2 | 3 | 4 | 5 | 6 | 7 |
| 15 | -4 | -3 | -2 | -1 | 0 | 1 | 2 | 3 | 4 | 5 | 6 | 7 | 8 |
| 8 | -3 | -2 | -1 | 0 | 1 | 2 | 3 | 4 | 5 | 6 | 7 | 8 | 9 |
| 4 | -2 | -1 | 0 | 1 | 2 | 3 | 4 | 5 | 6 | 7 | 8 | 9 | 10 |
| 2 | -1 | 0 | 1 | 2 | 3 | 4 | 5 | 6 | 7 | 8 | 9 | 10 | 11 |
| 1 | 0 | 1 | 2 | 3 | 4 | 5 | 6 | 7 | 8 | 9 | 10 | 11 | 12 |
| 1/2 | 1 | 2 | 3 | 4 | 5 | 6 | 7 | 8 | 9 | 10 | 11 | 12 | 13 |
| 1/4 | 2 | 3 | 4 | 5 | 6 | 7 | 8 | 9 | 10 | 11 | 12 | 13 | 14 |
| 1/8 | 3 | 4 | 5 | 6 | 7 | 8 | 9 | 10 | 11 | 12 | 13 | 14 | 15 |
| 1/15 | 4 | 5 | 6 | 7 | 8 | 9 | 10 | 11 | 12 | 13 | 14 | 15 | 16 |
| 1/30 | 5 | 6 | 7 | 8 | 9 | 10 | 11 | 12 | 13 | 14 | 15 | 16 | 17 |
| 1/60 | 6 | 7 | 8 | 9 | 10 | 11 | 12 | 13 | 14 | 15 | 16 | 17 | 18 |
| 1/125 | 7 | 8 | 9 | 10 | 11 | 12 | 13 | 14 | 15 | 16 | 17 | 18 | 19 |
| 1/250 | 8 | 9 | 10 | 11 | 12 | 13 | 14 | 15 | 16 | 17 | 18 | 19 | 20 |
| 1/500 | 9 | 10 | 11 | 12 | 13 | 14 | 15 | 16 | 17 | 18 | 19 | 20 | 21 |
| 1/1000 | 10 | 11 | 12 | 13 | 14 | 15 | 16 | 17 | 18 | 19 | 20 | 21 | 22 |
| 1/2000 | 11 | 12 | 13 | 14 | 15 | 16 | 17 | 18 | 19 | 20 | 21 | 22 | 23 |
| 1/4000 | 12 | 13 | 14 | 15 | 16 | 17 | 18 | 19 | 20 | 21 | 22 | 23 | 24 |
| 1/8000 | 13 | 14 | 15 | 16 | 17 | 18 | 19 | 20 | 21 | 22 | 23 | 24 | 25 |

**Exposure Value (EV) number** single number representing a range of equivalent combinations of aperture and shutter speed. Exposure Value unit is one stop

**light meter (exposure meter)** measures intensity of light for photography, giving value as a combination of shutter speed and aperture or a single EV number for a given film speed or sensitivity

## Light meters

Light meters are designed either to measure light reflected from the subject (the meter in your camera) or to measure light falling on the subject (a hand-held incident light meter).

Modern cameras use reflected light meters that work through the lens (**TTL**). They usually have adjustable sensitivity patterns. Centre weighting is common as this takes more account of the subject at the centre of the frame. So-called spot metering in cameras is better thought of as small-area metering; a true **spot meter** measures at a much narrower angle between 1° and 5°, which makes many camera 'spots' look crude indeed. However, camera spot meters are useful for making average readings from highlight and shadow areas. Evaluative metering is now found in many forms, with all major manufacturers having their own brand names. Essentially, the image is broken down into metering areas, sometimes over 1000. The brightness distribution that is measured is compared against a database of image measurements and compensation made accordingly. The modern meter will take into account not only the focal length of the lens but also the point on which the camera is focused, as well as the brightness distribution. Sophisticated modern meters will give perfectly acceptable results 90 per cent of the time but they can be fooled. More importantly, your visualisation of the scene may not be what the designers had in mind when programming the camera.

Hand-held incident light meters usually have a diffuser (sometimes called a lumisphere) over the light-sensitive cell to average the light falling on the subject. On some models, this can be moved aside and the meter used as an averaging reflected light meter by pointing it at the subject. Spot meters are simply reflected light meters that measure from a much smaller part of the subject. True spot meters use the narrowest of acceptance angles to pick the tiniest part of the subject for measurement. They usually use a simple telescope viewfinder. Some hand-held meters incorporate a zoom lens viewfinder to pick off spot readings from tiny areas of the subject ranging from 1° to 5°.

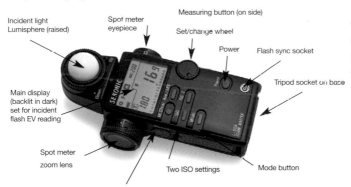

Incident light Lumisphere (raised)

Spot meter eyepiece

Measuring button (on side)

Set/change wheel

Power

Flash sync socket

Main display (backlit in dark) set for incident flash EV reading

Tripod socket on base

Spot meter zoom lens

Two ISO settings

Mode button

Memory button. Memory clear and average (on body)

Typical professional light meter with reflective spot metering and incident light meter modes for flash and ambient light.

**spot meter** light meter that takes a reflected light reading from a very small area of the subject (1–4° acceptance angle). Camera spot meter functions are commonly not as selective unless telephoto lens is used
**TTL (through the lens)** reflected light meter in cameras that measures light through the taking lens

## Exposure compensation

Reflected light meters are easily fooled as they expect to see an average scene. The reflectance of the average scene equates to 18% grey. Light meters try to interpret what they 'see' in terms of the average scene. A predominantly light subject will give too short a suggested exposure, often **underexposed** by 2 stops. Similarly, an all-dark subject will result in **overexposure** by up to 2 stops. Exposure compensation or manual override will be needed when the subject is not average – black dogs or white flowers filling the frame, for example.

## Exposure troubleshooting

| | |
|---|---|
| Side lighting or back lighting | Increase exposure by 1 stop |
| Beach or snow scenes | Increase exposure by 1 stop |
| Sunsets or scenes with bright light source | Increase exposure by 1 stop |
| To get a natural look for a very light or white subject | Increase exposure by at least 1 stop |
| In extremely contrasty lighting; shadow areas have important detail and are much darker than brightly lit areas | Increase exposure by 2 stops |
| Background is much darker and bigger than subject (a light skinned person against a dark wall) | Decrease exposure by 1 stop |
| To get a natural look for a very dark subject | Decrease exposure by at least 1 stop |
| Extremely dark background takes up a large part of the image | Decrease exposure by 2 stops |

| CHANGE | To increase by 2 stops | To increase by 1 stop | To decrease by 1 stop | To decrease by 2 stops |
|---|---|---|---|---|
| aperture (example) | Open aperture 2 stops (f8–f4) | Open aperture 1 stop (f8–f5.6) | Close aperture 1 stop (f8–f11) | Close aperture 2 stops (f8–f16) |
| OR shutter speed (example) | Reduce shutter speed 2 stops (1/60–1/15) | Reduce shutter speed 1 stop (1/60–1/30) | Increase shutter speed 1 stop (1/60–1/125) | Increase shutter speed 2 stops (1/60–1/250) |
| OR EV compensation | Set to +2 | Set to +1 | Set to –1 | Set to –2 |
| OR **film speed/sensitivity** (example) | Quarter (ISO 400– ISO 100) | Half (ISO 400– ISO 200) | Double (ISO 400– ISO 800) | Quadruple (ISO 400– ISO 1600) |

**film speed/sensitivity** measure of photographic film's sensitivity to light. See ISO

**overexposure** images created with too much light, having no shadows or dark tones. See underexposure

**underexposure** images created with too little light, no highlights or light tones. See overexposure

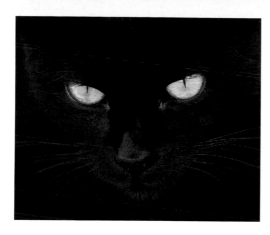

### Black cat (left)

The kind of subject that demands accurate metering. A reflected meter (in-camera) reading would produce – without exposure compensation – a mid-grey image of this cat.

**Photographer:** Brad Kim.

**Technical summary:** Canon EOS 10D, Canon EF 70–200mm f/2.8L zoom lens at 200mm focal length. Underexposed by 2 stops from the camera meter reading. Photoshop levels applied for final tonal adjustment.

### White tulips (below)

Another difficult subject to expose by using a reading from a reflected light meter. Without positive EV compensation (up to 2 stops overexposure on reading) these tulips would be grey.

**Photographer:** Marion Luijten.

**Technical summary:** Canon 10D Sigma 105mm 1/125 sec at f/13 ISO 400, lit by two Bowens Esprit 500DX monoblocs, one with softbox and one with umbrella.

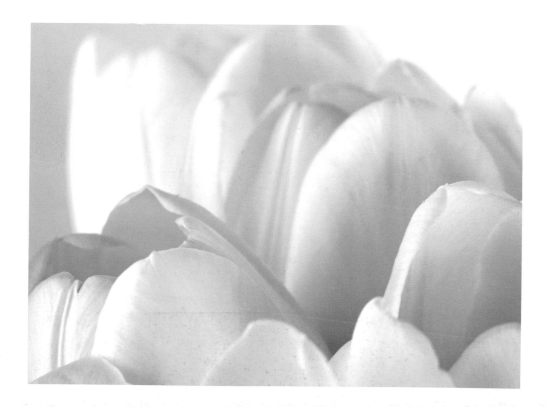

### Techniques for the perfect exposure
There are several ways of getting accurate meter readings. Never forget that meters always read for middle grey (18% reflectance).

### Take a general reading
Often a reading from an entire subject gives a good exposure. If the subject is predominantly light coloured or white then add light. (It is not intuitive. My memory aide is that 'Bright Students are A Plus' – so if the subject is bright I add (plus) 1 stop or more.) Conversely, for predominantly dark subjects cut down on the reading suggested by the meter. For the proverbial black cat, you will need to reduce the exposure by up to 2 stops.

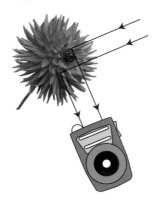

Reflected light metering.

### Substitute metering – use a grey card
An 18% reflectance grey card gives the meter what it wants to see. Hold the card in front of the subject and meter off that. Set the camera ignoring what the meter now tells you (if you leave the camera on Automatic it will automatically get it wrong – you must use Manual control with a grey card). If you do not have a grey card, use your hand held in front of the subject. Don't let shadows fall from your fingers and hold your hand out flat. Caucasian skin needs a stop more than the reading, so if the meter reads 1/125 at f/5.6 give it 1/60 at f/5.6. Brown skin almost matches a grey card perfectly. Dark skin may need up to 1 stop less than the meter suggests. Find out how your skin relates to a grey card reading.

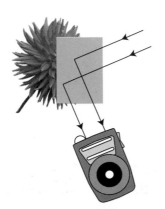

Substitute light metering
with 18% reflectance grey card.

## Measure the light falling on the subject

Using a hand-held incident light meter. Incident light meters supply an averaged reading of the light falling on the subject and do not read dark and light areas on the subject. This can be a good idea in extreme lighting conditions. Remember to point the meter back towards the camera position.

Incident light metering.

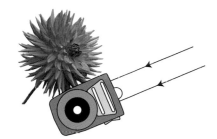

## Average the readings taken from the shadows and highlight

As meters read middle grey, the correct reading will be somewhere between the reading for the darkest and lightest areas of the subject. If the reading is 1/250 at f/5.6 at the lightest part and 1/15 at f/5.6, shoot at 1/60 at f/5.6, which is in between the two.

## Bracketing

One way to get the right exposure by playing it safe and taking additional under- and overexposed images. This may not be possible with some fast-changing subjects. Take any type of meter reading then shoot additional frames whole or half stops under- and overexposed in a series of three or five frames. Some cameras will do this automatically. This cannot work with candid photography where you get one shot only, so do not rely on the technique too much. It is great for still-life though.

## Meter the shadows and compensate

Metering shadows and compensating for them will guarantee that you get shadow detail. Take a meter reading from the darkest area where you want detail (cat's black fur, for instance). Then expose at 2 stops less. If the meter says 1/60 at f/2.8 use 2 stops less – 1/60 at f/5.6.

**bracketing** intentional over- and underexposure from the indicated exposure, usually in whole or half stops

## Subject contrast

Subject contrast is the difference between the lightest and darkest tones in an evenly lit subject. For someone dressed all over in grey there would be no contrast but someone dressed in a white shirt under a black jacket would have an inherent contrast of about 6 stops. To confirm this: on a bright but overcast day where the incident light reading was 12.5EV (ISO 100) a reflected reading from a white shirt was 15.5EV while that taken from a black jacket was 9.5EV. (Note that the incident light reading representing middle grey falls at exactly the half way point, three stops darker than white but three stops lighter than black.) This shows a range of 6 stops (15.5 – 9.5 = 6) which – referring to the stops to ratio table – gives a subject contrast of 64:1. A subject contrast of 6 stops is already challenging the ability of some colour reversal films even before any lighting has been added.

Subject contrast can be thought of as being the difference between the amounts of light reflected back by the different materials of the subject. We deal with subject contrast alone in open lighting in the real world; this is lighting that is flat and even, without shadows. If reflectors are introduced to highlight parts of the subject, or the subject itself is moved into areas of part shade, then we are no longer just dealing with subject contrast. In particular, as soon as we go into the studio and build up our own lighting things become more complicated and contrasty.

| | |
|---|---|
| 1 stop = 2:1 | High contrast is when the ratio between the lightest and the |
| 1.5 stops = 3:1 | darkest tones is greater than 32:1. |
| 2 stops = 4:1 | |
| 3 stops = 8:1 | Low contrast is when the ratio is less than 2:1 |
| 4 stops = 16:1 | |
| 5 stops = 32:1 | |
| 6 stops = 64:1 | |
| 7 stops = 128:1 | |

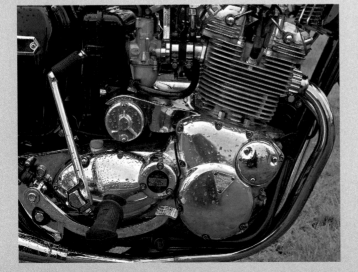

**Motorcycle engine (left)**

The subject contrast of this motorcycle engine already pushes the limitations of digital capture at 7-stops range on a cloudy overcast day. In bright sunshine, the reflections would push this range higher to 10–12 stops, meaning the highlight detail or shadow detail would be lost, depending on the chosen exposure. Dull days are sometimes the best for high contrast subjects.

**Photographer:** David Präkel.

**Technical summary:** Nikon D100, 28–85 f/3.5–5.6 AF-D Nikkor Zoom at 35mm, 1/180 at f/11, ISO 200.

## Subject brightness range

**Subject brightness range** is the combination of subject contrast and lighting contrast. If a subject with a contrast of 4:1 is lit by lights in a ratio of 8:1 then the overall subject brightness range will end up as 32:1. (This represents a range of 5 stops that can just be captured on transparency material.) Remember:

subject brightness range = subject contrast x lighting ratio

Subject brightness range can be thought of as the final contrast that the camera 'sees', made up of the combination of the inherent contrast in the subject and the contrast in the lighting applied. This is the reason it becomes so important in the studio to learn to see how the camera 'sees'.

Film and digital sensors are limited in the subject brightness range they can handle. Colour transparencies can only accommodate 5 stops, which is a brightness range of about 32:1. Black–and–white and colour negative films have about a 7-stop latitude, though black-and-white film can be under/overexposed and development compensation used to change what parts of the dynamic range are captured. Digital RAW files have greater latitude than JPEGs and can match or better black-and-white and colour negatives.

All too often, beginners will set up spectacular still-life shots or portraits in the studio. To the eye they look dramatic, but the camera sees something quite different and the resulting images are always disappointing. Even if a range of exposures has been made, they will go quickly from having all blocked-up shadow detail to having completely blown-out highlights – even the 'correct' exposure will show some problems with both highlights and shadows. This is because the camera does not have the same ability as the eye to seemingly see into the shadows almost at the same time as seeing detail in the brightness highlights. The trick in the studio is to learn to light for the camera.

Note: The average outdoor scene has a range of 7-stops (128:1) and it will come as no surprise that glossy black-and-white photographic printing paper (wet chemical, not inkjet) has the ability to show exactly this range of densities. Matt paper cannot show the same density of black and has a much more restricted dynamic range.

**subject brightness range** of light to dark presented to the camera by the subject is a combination of the subject contrast and the lighting ratio

## Subject brightness range = subject contrast x lighting ratio

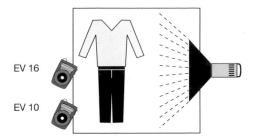

EV 16

EV 10

White shirt and black trousers
evenly lit
6 stops difference in reflected
meter reading
6 stops = 64:1 ratio

In an unlit studio subject has no contrast

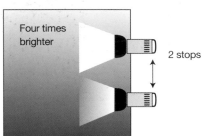

Four times
brighter

2 stops

Lighting ratio is 4:1

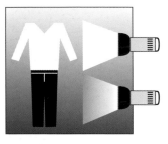

Light on white shirt is 2 stops
brighter than that on black trousers
Lighting ratio is 4:1
Subject contrast is 64:1
Subject brightness range is
4x64:1x1 = 256:1 = 8 stops   BUST!
This is greater than 7-stop latitude of negative
film or digital. Depending on exposure, you will
lose either highlights or shadow detail

Light on black trousers is 2 stops
brighter than that on white shirt
Lighting ratio is 1:4
Subject contrast is 64:1
Subject brightness range is
1x64:4x1 = 64:4 = 16:1 = 4 stops   FINE!
Exposure will record highlights and shadow detail

## Non-image forming light and lens shading

As well as the light that forms the image by being focused through the camera lens, there is also light that takes no part in image formation. Failure to deal with this light can result in poorly saturated colours or, worse still, lens flare.

Prime lenses are easier to shade with a dedicated lens hood than the now more commonly used zoom lenses with their variable angles of acceptance. A lens hood must not cut off the corners of the wide-angle image and will, therefore, offer little shade for a zoom lens at the other end of its focal length range. An alternative to the lens hood or lens shade is the flag, a simple black plate on the end of an adjustable arm that fits in the camera accessory shoe.

Studio photographers using **large format** cameras take lens shading very seriously and use adjustable bellows lens shades. With the image composed, the bellow shade is adjusted until it visibly crops the image on the view camera ground glass back; it is then backed off until it just disappears outside the image area. This cuts out all stray light.

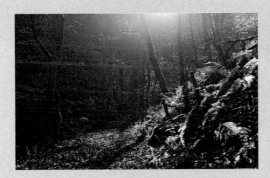

Unshaded

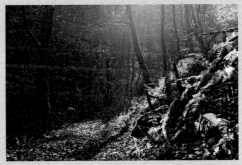

Shaded

### Burn Gorge, Northumberland (above)

Left: No lens shading and with sun on the edge of the frame. This **desaturates** colours and causes large lens flare.

Right: Same location, but f/4.8 with lens shaded by outstretched hand to stop sunlight falling on front element.

**Photographer:** David Präkel.

**Technical summary:** Nikon D100 60mm Micro-Nikkor AF-D 1/100 at f/5.6, ISO 200.

**desaturate/saturate** to decrease/increase the strength of all colours

**large format** sheet film in 5x4, 5x7 and 10x8 inch formats and larger, capable of recording the finest detail; the cameras that use this film

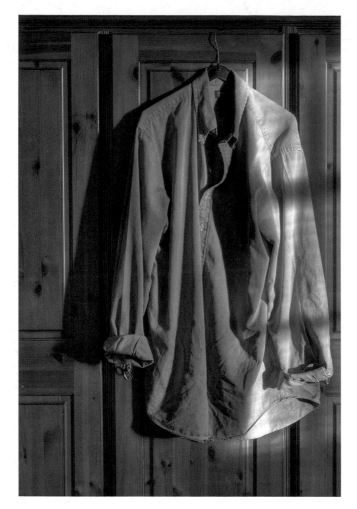

## Casual shirt (left)

Series of seven exposures, which were combined into a single 32-bit HDR image. This file was then tone mapped to best show highlight and shadow detail to match human perception of the original scene. If not carefully judged, tone mapping can produce very painterly effects. Created using Photomatix Pro software.

**Photographer:** David Präkel.

**Technical summary:** Nikon D100, 60mm Micro-Nikkor AF-D, ISO 400 base exposure 0.4 sec at f/11. Then +2EV, +1EV, 0EV, -1EV, -2EV, -3EV, -4EV.

| +2EV | +1EV | 0EV | -1EV | -2EV | -3EV | -4EV |

**High Dynamic Range (HDR) imagery**

The average outdoor scene has a range of 7 stops but many photographers work with the exception and not the average. Their high-contrast scenes will show a range of 10 or even 15 stops. The mass of digital images are commonly stored as 8-bit files that give a range of 8 stops, which is 256:1. Our eyes are capable of an instantaneous 1000:1 range. The eye and brain continually create a composite perception that exceeds even this range, meaning we can see into the shadows and into the highlights where the camera cannot.

The sensors in most digital cameras use 12-bit processing and can capture a range of 12 stops of 4096:1. Though these RAW (unprocessed) files can capture a much wider dynamic range, an 'instance' must be created on the computer that corresponds to just one exposure from the range of possibilities they contain. It would be better if we could take one exposure of the highlights from the RAW file and one from the shadows and combine them. Before Photoshop advances many digital photographers did just that and used layer masks to combine multiple RAW instances, or even different exposures, in one image.

Adobe introduced photographers to HDR imagery and 32-bit files when Photoshop CS2 was launched. This software feature allows users to merge a number of different exposures into a single file to more accurately represent the human perception of the scene. Though only two images are needed – no more than a stop apart – a series of images taken at regular intervals, say +2EV, +1EV, Normal exposure, -1EV and -2EV works best. These are merged into a single file that has an extended dynamic range with detail in both shadows and highlights. You physically have to take a series of images. Different outputs or instances from a single RAW file will not work well. Using images more than a stop apart can create poor quality output with banding. Despite the fact that HDR Merge offers some degree of image content alignment, it is best if the images line up closely. So, using a tripod is also important.

HDR Merge gives the photographer control both over contrast of the final image and of the ways in which highlights are handled.

Although HDR Merge can be used with landscape to create images that retain a natural feel – but with full detail in both highlights and shadows – the technique can have a specific 'look', rather like a super-realist painting. This could become stale if overused.

## Neutral density filters

Though it is more usual for photographers to be looking for yet more light or to eke out the available light, there are times when it is useful to be able to reduce light levels. Enter the Neutral density – or ND – filter. These filters reduce all colours in the spectrum evenly and therefore appear to be grey. They are available in a range of 'strengths'. An **ND filter** will reduce the amount of light entering the camera without changing the overall colour balance. They can be used with both colour and black-and-white film (but may push film into reciprocity failure) and digital cameras (though increased noise may result).

In what circumstances would you want to lose light? There are times you might need to create a picture under unexpectedly bright light when you have a high sensitivity film loaded. Some rangefinder camera lens combinations, for example, offer only 1000th of a second as the fastest shutter speed and a minimum aperture of f/16. With 400-speed film loaded, you can rapidly get into situations where you need to cut down the light entering the camera. Sunny conditions in high mountains can very quickly become too bright to work in without the help of ND filters.

Under the creative heading, ND filters allow photographers to use a wider aperture than would be otherwise possible. This permits shallow **depth-of-field** images to be created on bright days outdoors. Conversely, an ND filter will open up the opportunities of long time exposures combined with small apertures. This technique is a much-loved trick of the landscape photographer producing images of waterfalls as it gives the uniquely pictorial combination of milky, moving water and sharp front-to-back focus in the image. Photographs taken at the coast or the water's edge are a favourite for the use of ND filters.

Some manufacturers specify their filters as ND-2, ND-4 and ND-8. These admit half, quarter and one-eighth the light – easy to interpret as 1 stop, 2 stops and 3 stops reduction. Other filter manufacturers use the density 0.3, 0.6 and 0.9 descriptions for the same filters. Two filters can be used together but the filter factors must be multiplied, not added, together. Industrial strength filters are available from some manufacturers for specialist applications, such as solar photography and imaging the interior of furnaces and other high temperature processes.

**depth-of-field** apparent sharpness in front of and behind the exact point of focus; varies with format, aperture and focusing distance

**ND filter** neutral density filter that reduces light intensity equally across spectrum

## ND filter compensation

| ND filter | | Light transmitted | Increase exposure by |
|-----------|-------|-------------------|----------------------|
| 0.1 | | 80% | 1/3 stop |
| 0.2 | | 63% | 2/3 stop |
| 0.3 | ND-2 | 50% | 1 stop |
| 0.4 | | 40% | 1 1/3 stops |
| 0.5 | | 32% | 1 2/3 stops |
| 0.6 | ND-4 | 25% | 2 stops |
| 0.7 | | 20% | 2 1/3 stops |
| 0.8 | | 16% | 2 2/3 stops |
| 0.9 | ND-8 | 13% | 3 stops |
| 1 | | 10% | 3 1/3 stops |
| 2 | | 1% | 6 2/3 stops |
| 3 | | 0.1% | 10 stops |
| 4 | | 0.01% | 13 1/3 stops |

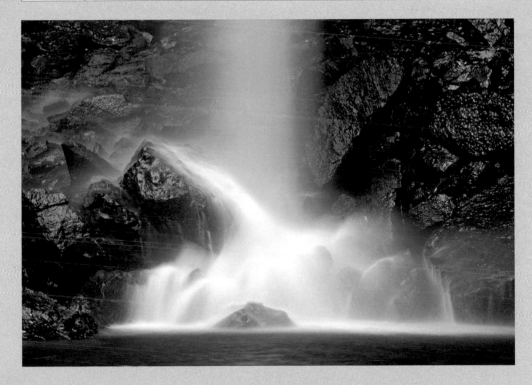

## Hardraw Force in Yorkshire Dales National Park (above)

A neutral density filter cuts down the light entering the camera and permits the use of long shutter speeds, which blurs the falling and cascading water into a misty, milky blur.

**Photographer:** Rod Edwards.

**Technical summary:** Mamiya 645 Super, Mamiya 150mm lens with 2x converter, 2 sec at f/11 with mirror lock up Fuji Velvia rated at EI40 for saturated colour not ISO 50, polarizer acting as ND 0.6 filter, cloudy and overcast.

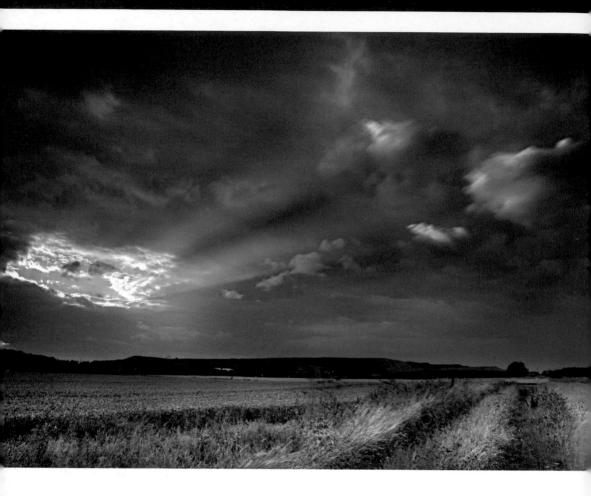

### Divine light (above)

Two graduated filters were used in combination to capture this image bringing detail into the sky.

**Photographer:** Adrian Wilson.

**Technical summary:** Canon EOS 5D, Canon 24–105 L f/4 IS zoom at 24mm, 2.5 sec at f/22, 2-stop and 3-stop graduated filters (Cokin P121M and P121S) used in combination with a polarizing filter. Contrast and colour saturation adjusted in Photoshop.

## Graduated filters

In the context of photographic filters, 'graduated' means a progressive or gradual change from one density (usually clear) or one colour to another. The most useful **graduated filters**, or 'grads' as they are commonly called, are the neutral density sets. These are employed to keep subject brightness range within acceptable limits in the camera and are widely used even with digital cameras, especially by landscape photographers.

A graduated neutral density filter can have two variables. Firstly, how much light the darker section cuts out; secondly, the speed with which the clear changes to the dark. You may find them described as L, M, S (Low density, Medium density or Strong) and Full, or as Soft and Hard, and they will have the usual ND designation (either density 0.3, 0.6, 0.9, etc. or the light loss ND-2, ND-4, ND-8).

The best ND grads are those made of resin, supplied as squares or rectangles. They are not screwed into the lens but fit slots in a holder that itself is fitted on to the lens. The filters and the filter holder can then be adjusted, not only to put the graduation strip into the correct part of the scene, but also by rotating the filter to accommodate hillsides or any time the composition puts the horizon on the slant. From this point of view circular glass graduated filters are very restricted in their use.

Coloured graduated filters have their uses but their application needs to be subtle; the graduated brown (tobacco) filter has been so overused in advertising images that incorporate landscape as to become a cliché. Sepia, yellow and pure blue grads can help the landscape photographer differentiate foregrounds and skies.

Unlike glass filters, grads are not coated to reduce reflections and saturation-killing flare, so they are best carefully shaded when in use to avoid unwanted reflections on their large flat surfaces. It is no coincidence that the manufacturer of the best grad filters also makes one of the best bellows shades.

No graduated filter    Low density          Medium density       Strong

**graduated filter (grad)** partly toned resin or plastics filter with slightly more than half of the filter clear. Clear to toned area has a smooth transition. Used to darken skies or control contrast

**High-key and low-key images**

High-key images should not be confused with overexposed images. A true high-key composition will show a full tonal range from black to white, but lighter tones will dominate. Overexposed images will not have any dark tones.

Some subjects – children in particular – are traditionally given the high-key look. It is important to understand both subject brightness range and the way light meters work to successfully light and meter a quality high-key image. It is easy to overexpose the image or accidentally blow out highlight detail. A decision must be taken as to whether a tone will be shown in the brightest 'whites' or whether the white will be intentionally 'blown out', allowing the printing paper to show through in these areas. Studio high-key images invariably use white backgrounds and plenty of even light is required on the background material to create the effect. To get an even-lit background, the lights must illuminate the opposite sides of the backing material from where they stand.

When metering a high-key subject, either use a hand-held incident light meter or use substitute metering from a standard grey card. Following the exposure recommended by a reflected light meter reading without using EV compensation would produce a mid-grey rather than a white image. With a digital camera, the histogram display becomes your guide – a high-key image will show a distribution towards the right of the display with the bulk of the histogram being above the central mid-grey point, but without clipping at the far right white point. Conversely, the low-key image will show a dark weighted histogram all below mid-grey, but with no clipping at the black point.

Low-key images have a serious and darker feel to them, literally and metaphorically. There are two ways to go about creating the low-key look. A composition with only dark items, when correctly exposed, will produce a low-key image. Alternatively, lighting can be used. A scene with a normal range of tones can be lit selectively, using the deep shadows formed to produce a low-key look. In the studio, non-reflecting black material (black velvet cloth rather than black paper, which can reflect a lot of light from its surface) and high contrast lighting achieve this low-key look. Simply underexposing a normal scene will not result in a low-key image, as there will be no highlights at all.

The difficulty with the low-key look is to keep sufficient shadow detail. Again, the incident light meter will help establish an accurate exposure; if a reflected meter reading is used without additional EV compensation the resulting image will look grey and washed out.

### Beauty 32 (above left)/Beauty 31 (above right)

High-key and low-key fashion images, both contain a full tonal range but are biased towards light tones or dark tones respectively.

**Photographer:** Stéphane Bourson.

**Technical summary:** (both) Canon D60, ISO 100 (32) Canon 100mm f/2.8 Macro EF, 1/200 sec at f/16. Flash on background, two reflectors on model, one flash head with beauty dish higher on the face and one spotlight with diffuser lower. (31) Sigma 28–70mm f/2.8 EX DF at 70mm, 1/125 at f/16. Two Profoto flash heads with softboxes at 45° to each side of the model. Make-up: Magalie Fockeu.

Low-key image

High-key image

## Polarized light

Unlike other filters, **polarizers** affect the physical characteristics of light, not its colour. Light from the sun spreads in waves in all directions, but lightwaves reflecting off a smooth surface tend to be oriented in the plane of that surface. The polarizing filter has a molecular or crystalline structure that lets light through at one angle, but not another, and can be rotated to block most of the reflected light. Colours will be more saturated and reflections from metallic or water surfaces eliminated or reduced, but the polarizer must be orientated correctly to work and the sun must be shining.

Polarizing filters are neutral in colour. As well as getting rid of unwanted reflections, they have some effect on contrast and colour saturation, working equally well with colour, black-and-white film or digital. Polarizers are useful beyond just darkening skies and getting rid of reflections in glass windows. They can change the reflections from water and show the colours beneath shallow waters. Using a polarizer on brightly lit foliage can increase the colour saturation by reducing the effect of unwanted reflections. Similarly, they can greatly improve the colour rendition of brightly lit rock faces.

Outdoors, the area of blue sky at right angles to the sun can be darkened by a polarizing filter – wide-angle lenses show this effect as a distinct, darkened band in the sky, which can look unnatural. This explains why the advice when using polarizers is to have the 'sun on your shoulder'. Their effect is most noticeable at an angle of 90° to the sun.

Linear polarizers are for use with large and **medium format** cameras, manual viewfinder/rangefinder and SLR cameras without meters. Circular polarizers (C-Pol) are the only polarizing filters that work with modern cameras having TTL meters and auto focus, though they are more expensive to buy than simple linear filters. Camera TTL meters will make adjustments for the light loss that occurs with polarizing filters, but with an incident light meter you must follow the filter manufacturer's instructions and give an extra $1^{1}/_{3}$ to $1^{1}/_{2}$ stops exposure to compensate for the light loss.

Some photographers use polarizers in combination with other filters, like 81 series warm-up filters for colour, or with red filters for truly dramatic skies with black-and-white film.

**medium format** 6x6.45, 6x6, 6x7, 6x8, 6x9cm formats on 120/220 roll film
**polarizer** used over lens to control reflections from non-metallic surfaces and to darken skies at 90° to the sun

### Boat cemetery (above)

Not only will a polarizer darken the sky but it can also be used to control reflections from the subject and to saturate colours.

**Photographer:** Jean Schweitzer.

**Technical summary:** Canon 20D, Canon EF-S 17–55mm f/2.8 zoom at 20mm, 1/200 sec at f/10, ISO 200. Daylight with circular polarizing filter. No Photoshop adjustments.

## Imaging at the ends of the spectrum

### Black-and-white infrared

Beyond the 700nm limit on visible red, the electromagnetic spectrum extends towards microwaves by way of the so-called 'near' infrared to the 'far' infrared. 'Far' infrared is the province of radiant heat and thermal images produced in false colour by dedicated thermal imaging cameras – infrared photography concerns itself with the 'near' infrared part of the spectrum only.

Conventional silver halide film can be produced to be sensitive to 'near' infrared light. It is exposed for best results using filters over the lens to block most, if not all, of the visible spectrum. The resulting image is white where IR is reflected and black where it is not. Leaves, for instance, reflect infrared and appear white, while the sky appears dark. This film tends to be very grainy and has no anti-halation layer to stop reflections within the film, so the resulting images have a very characteristic gritty, diffuse and almost ghostly effect showing white leaves and grass against dark skies.

The development of digital photography has meant a recent loss of film choice for the photographer wanting to explore infrared. There is still a wide choice of infrared filters, however. These give different cut-off points in the spectrum. Infrared filters are usually described by the wavelength where they begin to act – a RG695, for instance, would filter all visible light below 695nm. Filters for infrared are: RG610, RG630, RG645, RG665, RG695/Wratten 89B, RG715/Wratten 88A, R72, RG9, RG780/Wratten 87, RG830/Wratten 87C, RG850, R90 and RG1000. Some photographers use red/Wratten 25 or dark red/Wratten 29 filters to allow a little visible light to be included.

Infrared light does not focus at the same point as visible light. Some lenses are marked with a red dot to show the necessary offset for correct IR focus. When using some of the above filters – those that completely block visible light – it is necessary to focus with no filter, move the lens focus as indicated and then fit the filter. Camera light meters do not work with these filters and exposure has to be by calculation, experience and experimentation.

### Digital infrared

Digital infrared photography started promisingly. Early cameras produced superb digital IR images with R72/Wratten 89B filters, if at 3MPx or less – low resolution by today's standards. However, as manufacturers began to offer higher pixel counts and cameras have become more sophisticated, extended infrared performance has been limited in an effort to reduce the appearance of IR contamination effects in visible light images. With today's cameras, a solid support, long exposures and noise reduction software are essential.

## Canary Cottage at Thorney in fens near Peterborough, Cambs (right)

Infrared images on film have a ghostly and grainy quality that gives a sense of other worldliness.

**Photographer:** Rod Edwards.

**Technical summary:** Nikon F90X, 24mm Nikon lens, 1/30 sec at f/11, Kodak High Speed Infrared with a Cokin Red Filter, developed in Agfa Rodinal to exaggerate the effect. The image was scanned at a high resolution and the local exposure adjusted in Photoshop, particularly around the edges of the frame as it isolates the cottage and almost makes it spotlit. The warm brown tone was added in Photoshop and the door darkened to complete the composition.

## Church on a hill (left)

Digital black-and-white infrared imaging has a much cleaner look, though the strength of the effect depends wholly on the camera's sensitivity to infrared and the severity of the filter used (the degree to which it cuts out visible light).

**Photographer:** Ilona Wellmann, Trevillion Images.

**Technical summary:** Canon G1 with Hoya Infrared R72 filter and tripod, 1/8 sec at f/20. The original muted colour was desaturated and then duotoned in Photoshop.

## Colour infrared

Colour infrared film records infrared energy as a false colour. Two film emulsion layers capture green and red light but a third is used to capture the infrared. The film is exposed through a strong yellow filter – usually a Wratten 12 – to prevent the final image being too strongly violet. Film transparencies are produced by processing in any E6 reversal chemistry (a scientific AR-5 process is also available in a limited number of labs). The colour shifts that occur when using a yellow filter are: red is imaged as green, yellow becomes blue-green and infrared shows as red. Other effects are possible with orange, red or green filters. There is no way to produce this look in-camera with digital.

**aeRial (top left)**
**divergence (bottom left)**

Images of harvesting taken from a light aircraft above the Eden Valley in Cumbria flying at an altitude of about 1200ft (365m). These are the true colours from the scanned film.

**Photographer:** Gill Wilson.

**Technical summary:** Olympus OM2, 35–70mm Zuiko Zoom, orange filter (aeRial), yellow filter (divergence) on Kodak Ektachrome Infrared EIR film, ISO 200, E6 processed.

## Digital colour infrared

Because of the known colour shifts, it is possible digitally to mimic the look of colour infrared using Photoshop's channel mixer palette (Red output channel set for -100R +200G, Green output channel -5G +100B and Blue output channel +100R is the place to start experimenting). This is not true infrared as the image is only created by visible light.

### Digital infrared (above)

Digital infrared look (right) created from colour original (left) in Photoshop.

**Photographer:** David Präkel.

**Technical summary:** Nikon D100, 18–35mm f/3.5–4.5 AF-D at 35mm 1/400 at f/9.5.

### Ultraviolet and fluorescent photography

Unlike infrared photography, ultraviolet (UV) photography does not use film sensitized to ultraviolet light. Instead, conventional colour film is used to record the effect of ultraviolet light on materials that fluoresce – that is, they emit visible light when exposed to invisible radiation. The effect is familiar from 'black light' tubes used in nightclubs that make your teeth and any clothing washed with 'laundry brighteners' glow in the dark. This should really be called fluorescent photography.

The filters used to enhance the fluorescent effect are commonly light yellow filters (420/Wratten 2A, 415/Wratten 2B and Wratten 2E) that block some blue and the illuminating ultraviolet. The 415 filter is colourless and stops the cement in the lens itself fluorescing and causing haze.

True UV photography – scientific or crime scene photography in UV light – uses a different approach with a Wratten 18A filter to block visible light and record only the illuminating UV on black-and-white film. Of course, both techniques are open to experimentation for the artist/photographer.

Note: one of photography's little confusions is that while IR filters block the visible spectrum and pass only infrared, what are commonly called UV filters are designed to block ultraviolet (to reduce the blue appearance of haze) and pass only the visible spectrum.

### Una in ultraviolet (above)

The striking colours of ultraviolet fluorescence

**Photographer:** Juergen Specht.

**Technical summary:** Nikon D2X, Nikon 20mm lens. Camera attached to the ceiling above the model lying on a white UV-sensitive sheet, lit with 11 UV (black light) 40 watt fluorescent tubes, each about 120cm long. No filters or Photoshop effects.

Patience is the one attribute a photographer must have when dealing with natural light. Throughout a day, the colour quality of the light changes from the unique golden pinks of the first light of dawn, through the harsh white light of noon to the rich yellow glow of evening. Not only do the colours change, but the direction and angle of the light changes as the sun rises, transits the sky and sets.

The photographer's job is to pick the moment when the 'light is right' – some photographers are prepared to wait hours for the sun to be in the right position; others will wait months for the seasons to change and finally bring illumination back on to some natural feature. There are certain dramatic landscape features – slit canyons, waterfalls in gorges, for example – that are only fully lit for a few hours on a few days of the year. Compositional aspects, how the light models the land to create form and texture from landscape features, are the important considerations.

The sun is a single point source of light, of varying colour temperature, moving up and around subjects in the real world. Some aspects may never receive its direct light (north-facing cliffs in the Northern Hemisphere, for instance). The qualities of daylight – colour temperature, whether it is diffused or harsh, its angle (elevation) and direction – are associated with certain moods and feelings. Knowledge of these is also useful to the studio photographer who wishes to recreate a certain mood using controlled lighting in the studio – for example, strongly yellow light casting long shadows would evoke feelings of an autumn evening.

A landscape photographer will work with the sunlight, choosing time and viewpoint to best illuminate the subject. There are photographers who use studio reflectors and cutters in the sunlight to shape natural light in the way they want. Many fashion photographers working on location will use cutters and reflectors to direct and alter the quality of the basic sunlight, perhaps benefiting from the strength of midday sun but preventing it from falling directly on to the model or reflecting it into more shaded settings.

**'A photographer must be prepared to catch and hold on to those elements which give distinction to the subject or lend it atmosphere. They are often momentary, chance-sent things... Sometimes they are a matter of luck... Sometimes they are a matter of patience...'**
*Bill Brandt (photographer)*

## Sunrise (facing opposite)
The first rays of the morning sun on the windmill and marshes at Cley-next-the-Sea, on the North Norfolk coast.

**Photographer:** Rod Edwards.

**Technical summary:** Mamiya 645 Pro TL, 45mm lens, 1/8 sec at f/16, Fuji Velvia rated at ISO 40, with warm up filter, exposure set for sky.

## Daylight

In everyday speech, we use the word 'daylight' very loosely. However, it has a very special meaning in photography. **Daylight** film, or daylight white balance on a digital camera, is a closely defined quality of light. Photographic daylight has a colour temperature of 5500K. This was the choice of film manufacturers for colour film to be exposed roughly between 10 a.m. in the morning and 4 p.m. in the afternoon to give acceptably neutral whites.

Photographic daylight is based closely on the measurements of mean noon sunlight (5400K), which is an average of sunlight, measured at 12 noon in Washington, DC every day between the summer and winter solstices. This was chosen as a standard because these measurements had already been taken by the US National Bureau of Standards.

Daylight is not the same as sunlight as it is a combination of direct light from the sun, from the sky (**skylight**) and reflected light from the clouds. A cloudy overcast day, when the sun is not shining, is much bluer than many people think. It is worth remembering that any light that falls into the shadows of an image are illuminated by the skylight alone, which has a far higher (bluer) colour temperature than sunlight. This is one of the reasons a digital camera will have a specific colour temperature setting for 'shade', as well as 'daylight' and 'cloudy' settings.

The quality of daylight can be dependent on the prevailing weather conditions. Conditions that many amateurs would probably reject as unsuitable for photography can produce very satisfying lighting.

It is possible to predict where the sun will rise and set at any time of year and to work out how high it will rise in the sky and at what time. The simplest solution is a pocket **sun compass**. Once aligned, this shows the direction of the rising and setting sun for each month (greater precision is rarely needed). A second scale shows the maximum height the sun will reach in the sky in any given month. Using this to sight on a hill, for instance, will tell you if the sun will clear that particular feature.

The use of **sun tables** is more the province of architectural than landscape photographers. These tables show in detail the exact progression of the sun through the sky, where it will rise and set, and what elevation it will reach at any time of the day. Architectural shots can therefore be planned down meticulously to the month and time of day when a certain building will be lit in a particular way.

**daylight** average summer sunlight as measured at noon in Washington, DC, USA corresponding to a colour temperature of 5500K

**skylight** light of blue quality reflected from atmosphere; mixed with direct sunlight and reflected light from clouds it gives daylight

**sun compass** magnetic compass marked to show where the sun will rise and set at any time of the year

**sun tables** published charts that give the direction and elevation of the sun at any time of day throughout the year. Especially useful for architectural photography

## Excavate (above)

Saltburn-by-the-Sea, British east coast – a light that almost defines photographic daylight.

**Photographer:** David Präkel.

**Technical summary:** Nikon D100 28–85mm f/3.5–4.5, AF-D Nikon zoom at 31mm ISO 200 1/500 at f/11.

### Sun compass

A sun compass is a magnetic compass marked to show where the sun will rise and set at any time of the year.

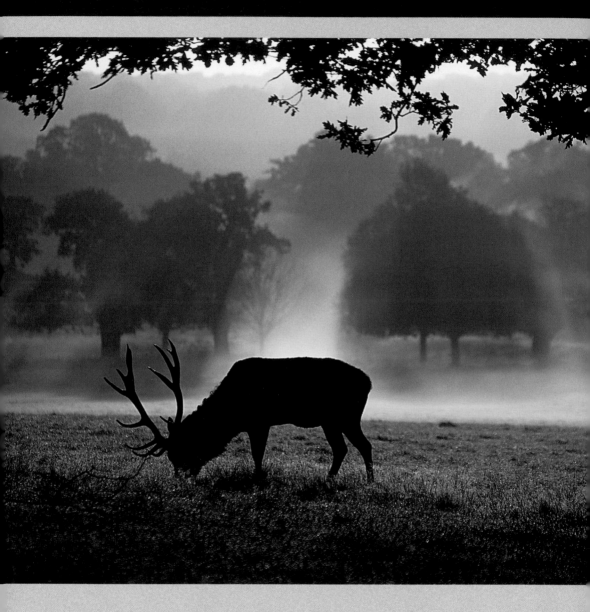

### Early morning deer (above)

An image composed entirely from the palette colours of morning sunshine yellow and gold. Low-angled back light has produced silhouettes from foreground objects while the mist has simplified background detail and made visible fingers of light through the trees.

**Photographer:** Andy Flowerday.

**Technical summary:** Pentax Z1-P, Sigma 70–300 zoom, Fuji Velvia ISO 50.

### Morning light

The time immediately before and after sunrise is a magical time for photographers. Before the sun rises, the light is richly red towards the rising sun and deep violet blue away from it. Immediately before the sun rises, this light will become pinker, only becoming golden yellow as the sun breaks over the horizon. When there is a mist on the ground, before the sun's heat has burned it off, it is possible to point the camera straight into the rising sun. Light is dramatically scattered, which reduces detail while emphasising shape. Silhouettes created in this way cast eerie shadows towards the photographer through the mist because of the strong backlighting.

Low sun demands respectful handling. Lenses must be carefully shaded if flare is to be avoided and colours kept saturated. Nevertheless, even flare can be used creatively. Bursts of light from reflections inside the lens become the symbolic equivalence in the final image of a viewer having to screw up his or her eyes against the sun. Zoom lenses will show the greatest flare and internal reflections; simply constructed prime lenses the least.

Photographers who take their opportunities early in the morning will be able to produce good images on more days than the average, as days that later turn to rain frequently dawn clearly. The early rising photographer is often rewarded with a stillness, light and colours not often experienced by the majority of people.

### Noon light

Noon summer sunlight, when the sun is at its highest point in the sky, is often considered too harsh for photography, though it is in this kind of light that many amateur snapshots are taken. Sunlight high in the sky may produce unattractive shadows below the eyes and cause squinting, though it does give saturated colours. The biggest problem is that overhead light gives little or no modelling on landscape features and, as mentioned, produces ugly shadows on faces.

The solution for fashion or portrait photographers is to use all the available noon light but shape it for photographic ends using reflectors and cutters; more details of using these items can be found in the chapter on Controlling Light. Scrim can break up harsh light. The simplest to use outdoors – given a wind-free day or plenty of assistants – are large white polystyrene flats as reflectors, which can be painted matt black for use as cutters or black bounces. There is a wide range of commercial reflectors and scrims available – probably the best known being the lightweight California Sunbounce system with 2-metre square reflectors light enough to be held by one assistant. For portraits and fashion photography using overhead noon lighting it becomes almost essential to use a reflector parallel with the ground to throw light back up into the shadows.

Without shadows, landscape forms are not revealed and, though well lit, noontime landscapes shot in summer can look flat and lifeless. However, in winter the noonday sun will barely rise 25° above the horizon (at a latitude of 50°N (London)). It will reach higher elevations the further south you go. Winter noon light will model landscape features well and has a warmer colour balance than photographic daylight, making warm-up filters redundant and the resulting images particularly attractive.

**Fashion shoot with reflectors**
Two reflectors on stands with a diffuser above the model to break up direct sun from overhead; black bounce behind will emphasise the effect of the reflectors. Scrim to the right of the model. Note the small shadows directly beneath objects showing how high the sun was in the sky.

**Noonday church (above)**

Near overhead sun produces strongly saturated colours on this painted church near Oia on the Greek island of Santorini. Note the shallow shadows beneath the arch.

**Photographer:** Rod Edwards.

**Technical summary:** Nikon D2X, Nikon 28–105mm f/3.5–4.5 zoom at 55mm 1/80 sec at f/11, ISO 100.

## Evening light

From mid-afternoon onwards the morning's progression of light is reversed. Colour is not the only attribute of evening light as it is still apparent in a black-and-white photograph taken during the evening. We judge evening light by the lower power of the sun and the length of shadows it casts. While morning light is seen as soft and diffuse, evening light is a stronger, low-angled source that casts long shadows. Now that all morning mists will have long been burned off, images will be crisper.

Sunsets are possibly the most photographed of all subjects. The rich red and gold evening colours never fail to please the eye and often tap into deeper emotions. Early digital cameras did not have a good track record with sunsets, as they would 'correct' the white balance, reducing the richness of reds and yellows. Some digital compact cameras now feature 'sunset' modes to add these colours to even mediocre sunsets because these kinds of images are so popular.

It is possible on hazy days to include the orb of the sun as a golden-red disk seen through the atmosphere. A very long telephoto lens will be needed to make the disk large enough in the frame. As with all photography where the sun is included, you must be careful of your eyes when looking through a camera pointed anywhere near the sun.

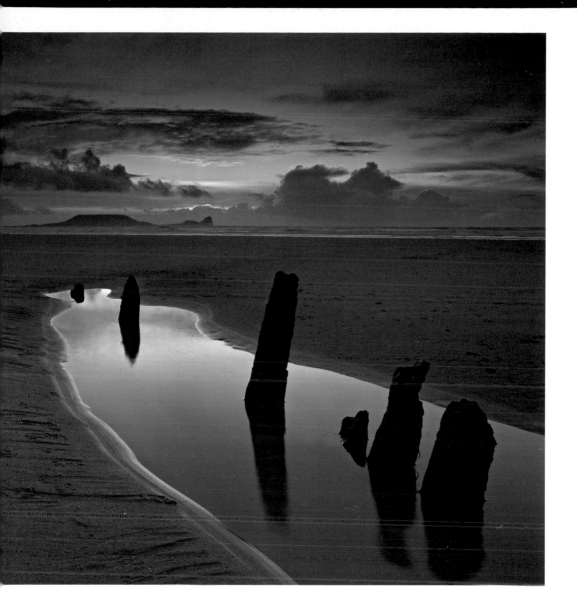

### Remains of the day (above)

Wreck of the ship *Helvetia* in Rhossili Bay, Gower Peninsula, South Wales. Careful choice of camera position gets the red sunset clouds reflected in the water pool as well as the brighter blues of the overhead sky.

**Photographer:** Adam Burton.

**Technical summary:** Canon 5D, Canon 17–40L, ISO 50.

# Night

The darkness of night can be both a security and source of fear. It is how light is introduced to illuminate the darkness that creates one feeling or another. At night, our light sources can swing around to illuminate the unexpected, which sometimes startles us. Torches and car headlights are commonly used in the cinema to create suspense before some secret or horror is revealed. The photographer too can use this pooling of light and darkness by carefully controlling a simple light source – possibly making the light cone visible with mist or smoke – while allowing deep shadows to hint at what may or may not be there.

Night also offers an inky black or softly coloured backdrop depending on the degree of light pollution. The cover of darkness is an ideal time to open the camera shutter and paint a subject with light from a torch or flash; this idea is covered in the last chapter, Using Light. Night is very rarely without some light; the three quarters or full moon is a surprisingly bright reflector of sunlight. This can illuminate cloud and produce an eerie light that – given enough exposure – can make moonlit landscape images look as if they were lit by soft daylight.

At night, readings from a sensitive hand-held light meter need to be interpreted carefully as they will give an exposure to produce mid-grey. Modern multi-segment camera meters make an excellent job of metering difficult night time images; the histogram should be below the centre line, accurately depicting the darkness. Use EV compensation if the camera has a tendency to overexpose dark subjects.

### Tripods – light extenders

Photographers sometimes jokingly refer to their 'light extender', by which they mean tripod or other camera support. Available light photographers, looking to get a sharp image in low-level light, will lean to support themselves. Better still is to hold the camera itself against a firm surface like a table or wall – a thin piece of plastic can be used to protect the camera.

Best of all is the tripod. Though sometimes inconvenient for photographers on the move, a good tripod can guarantee an image when it would not otherwise be possible. A 'good' tripod is not necessarily a heavy tripod but a solid one with an easy-to-use head and preferably a quick-release plate for convenience. Choose a tripod you can carry (carbon fibre or other lightweight but strong construction), as this will encourage you to take it with you and use it. Three 'rules' govern the correct use of a tripod: 'one leg under the lens'; 'thick before thin' (leg extensions) and use the centre column only as a last resort. Think 'health and safety' before using a tripod in a public place.

A cable release, wired switch or remote is used to fire the shutter without shaking the camera. The self-timer can be used to trigger a camera if you don't have a cable release – just as long as you don't need to time a shot. If the camera has mirror lock up and it is possible to use it, do so.

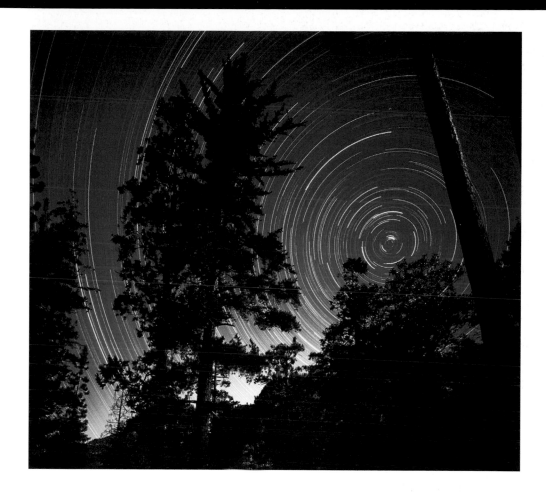

## Polar star trail (above)

Classic star trail photograph taken in Kings Canyon National Park, California, USA by pointing the camera at the Pole Star around which the sky appears to turn. Final image combines a long exposure by moonlight with a daylight exposure made the next morning.

**Photographer:** Kit Courter.

**Technical summary:** Zone VI Studios 5x4 wooden field camera, Schneider 90mm f/8 Super Angulon, main image Provia 100F 3.5-hour at f/8, daylight image made on black-and-white negative film was intended to put some texture into the deep shadow areas of the moonlight image. The two film images were both scanned with an Epson 4870 and combined in Photoshop. The colour image was used as the background with the black-and-white image – given a slight blue tint – as a Layer with 15% opacity and Overlay blending mode.

## Seasonal quality

Since photography was 'discovered', its practitioners have charted the changing seasons. Putting aside the abundance of seasonal subject matter, the light itself changes dramatically from season to season. This is partly because in a familiar landscape different features are illuminated by the sun on its seasonal progression, but also because the quality of the light and its elevation changes with the seasons just as it does during the progress of the day. Winter light will have a lower colour temperature and fall across the landscape; summer light will have a much higher colour temperature and, in June and July at the latitude of London, it will reach about 60° elevation above the southern horizon. Only at the Equator is the sun directly overhead in the summer months.

### Seasons of the tree (below and facing opposite)

This year-long cycle of photographs of a tree was undertaken as part of Spence's graduation exhibition where she charted a number of trees in different locations at times throughout the year. Meticulous planning is the key for such a project. Once a tree and view were identified, the camera position was established using a compass and string so the exact camera location could be re-established using the tree as a reference point.

**Photographer:** Becca Spence.

**Technical summary:** Nikon D50, 18–55mm DX AF-S Nikkor, ISO 200. Summer: 1/5 sec at f3.5, Autumn: 1/125 sec at f/5.6, Winter: 1/80 sec at f/4.5, Spring: 1/125 sec at f/5.6. No filters and no Photoshop.

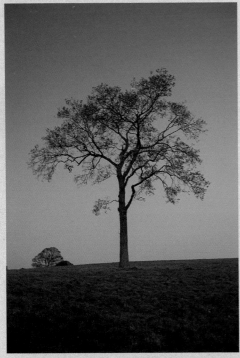

Summer

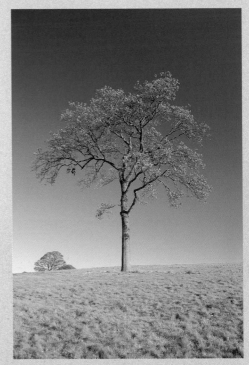

Autumn

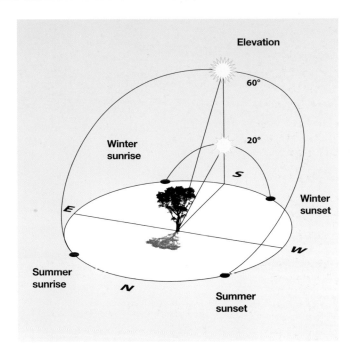

Elevation

60°

20°

Winter
sunrise

Winter
sunset

*S*

*E*

*W*

Summer
sunrise

*N*

Summer
sunset

The sun rises in the east and sets in the west but the seasonal variation is marked – sunrise and sunset at the winter and summer solstices are much further north or south than you might imagine (diagram true for 50°N London).

Winter

Spring

## Effect of location

It is important to be aware of how location will change the quality of light, and sometimes its quantity. Altitude can have a major impact on the quality of light even within the same small geographic area. The quality of light in a river valley will be quite different from that at the top of a nearby mountain. Not only will the valley light have some reflected component, there will be atmospheric effects to take into account. The air in the valley bottom will be moisture laden and will scatter the light to a greater or lesser extent.

Light at a mountaintop will be direct and unforgiving – at least on real mountains rather than hills. It will be quite blue and have a stronger ultraviolet component than light that has travelled through the atmosphere to reach the ground. Photographers used to describe the unique light in high mountains as Alpine light. It is one of the few times that a UV filter has any noticeable effect on an image as, without one, distant views taken in the mountains can appear hazy in apparently clear weather.

Coasts are favourite locations for photographers, not only for the subject matter and for landscape forms found there but because of the light quality. Both sea and beach act as giant reflectors of the overhead sun. The atmosphere itself will also play a large role in how light is seen as sea spray or even blown sand will scatter the light.

Light in the city is quite different from light in the open country on the same day and even under the same sky. Tall buildings block anything but the light from overhead, while their vertical surfaces will reflect light into some unexpected corners. Pollution will make its presence felt in any city image taken with telephoto lens in a yellowing or browning of the atmosphere.

### Fishing the light (above)

Atmospheric diffusion and low-angle light reduces the colour palette and creates a semi silhouette from the fisherman in the foreground.

**Photographer:** Jorge Coimbra.

**Technical summary:** Canon PowerShot G3, 1/250 sec at f/8, ISO 50. End of afternoon with some fog in the beach. Brightness and contrast adjusted in Photoshop.

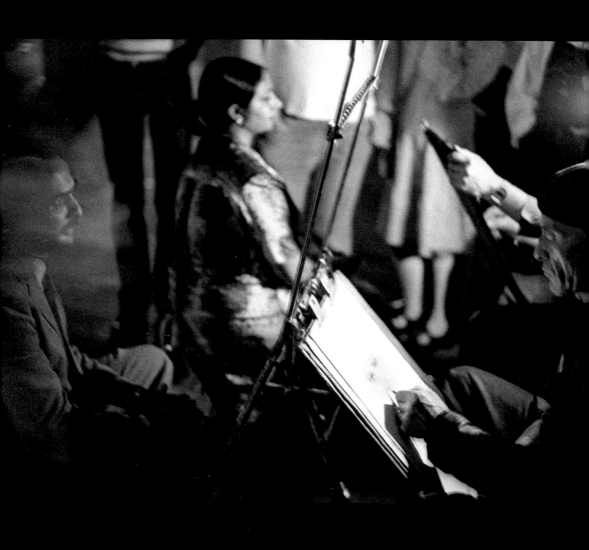

Available light photography is commonly associated with image making in low-level light, though this need not necessarily be the case. This chapter looks at all types of light other than natural light and light that has been produced exclusively for the purposes of photography. One of the best ways to think of this is as 'found' light; it is the photographer's job to make the best of what light there is, both in terms of quantity and quality. It may include some proportion of natural light. Some people refer to this as 'ambient' light.

Colour film is balanced either for daylight and flash, or for studio tungsten light where the colour temperature is both known and controlled. Moving from the studio into the real world of shops, hospitals, factories, homes and the office, the light available there for image making is anything but colour temperature controlled, possibly coming from mixed sources with very different colour temperatures. The film photographer might want to balance the colour temperature of light sources carefully to the film stock in use. In mixed light conditions, it may even be possible additionally to filter one light source using gels. Medium and large format film workers can proof their images on suitable instant Polaroid material, but the 35mm photographer is less well placed. The digital photographer can custom balance for white whatever the light and, when shooting RAW files, can delay the decision over colour balance until a specific 'instance' is created from the RAW file on the computer. This sets a particular colour balance and exposure.

The above remarks relate mainly to photographers working commercially in available light; art photographers may care little about the balancing of film stock to light, and for those working in black-and-white any light is good light when it can contribute to a good exposure. People shooting with available light explore the limits of illumination both in terms of illuminant type and in terms of low levels. Here, the need is to extend the duration of the exposure, and camera support and stability should be considered carefully.

### 'Available light is any damn light that is available!'
*W. Eugene Smith (social documentary photographer)*

### Street artists at night – Piccadilly, London (facing opposite)
A couple sit with separate artists to have their 'likenesses made', the only light is from camping gaslights hung at shoulder height or on the ground. Long exposure made when closest artist pauses but a figure enters from the left and leaves during the exposure.
**Photographer:** David Präkel.
**Technical summary:** Nikon EL2, 50mm f/1.4, Ilford FP4, lens fully open, 1/4 sec hand-held, scanned with local dodging and burning in Photoshop, brown toned to match warmtone darkroom print.

# Flames

Candles, oil lamps and flames have the lowest colour temperature (commonly 1500–2000K) of any light source, but possess a richly attractive golden light. They are usually single sources of light but make for dramatic lighting effects when massed together. A single candle will give bright highlights and deep shadows but a bank of candles gives a unique soft glow.

Firelight is the trickiest light to deal with in this category. With just the slightest flickering, the light will change both in intensity and in colour temperature; flames fanned by the wind will have a slightly higher colour temperature than a settled fire where the glowing embers contribute. With long exposure times, the flickering is integrated into a subtle, diffuse quality of light that can be very attractive with portraits (if the sitter is patient and will sit quite still). The very use of firelight suggests an intimacy, and if portraits are taken in firelight they will show the practical application of the inverse square law mentioned in the first chapter (see page 13) in the rapid fall-off of light beyond the subject.

Though some degree of adjustment is required to the white balance, it is important not to over correct images taken in candle or firelight as we do see and appreciate quite a strong degree of yellow in their light.

The particular attractiveness of candlelight is that it pools around the source of light and falls away rapidly; this means there will be a massive dynamic range between the source(s) of light itself and the deep un-illuminated shadows. Choices have to be made whether the exposure will favour shadow detail and reproduce the light as glare with blown-out highlights, or whether the area close to the light source will be placed much lower on the tonal scale and all thought of shadow detail forgotten. Both approaches have merit. Any decision will be dictated largely by the subject and by the way in which the photographer wishes to depict the scene.

The biggest difficulty in taking pictures of subjects lit by candle or oil lamps is getting enough light. Using faster films or increasing digital sensitivity will help, but will come at the cost of increased grain or, in the case of digital, increased noise. The longer exposure times required mean either using a tripod, or where that is not appropriate or possible, using an improvised support to steady the camera.

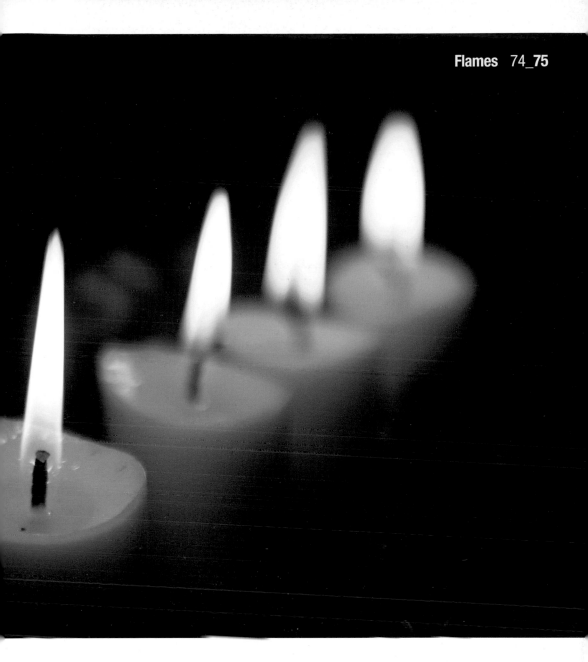

### Winter candles (above)

The distinctive rich yellow light of candle flame. A single flame is a point source and will cast strong shadows but a group of candles produces an attractive glowing light.

**Photographer:** Jean Schweitzer.

**Technical summary:** Canon 20D, Tamron SP AF 28–75mm f/2.8 Aspherical (IF), 1/320 sec at f/2.8, ISO 200.

**Swedish nights (above)**
Less rich than candlelight but nevertheless distinctly yellow, domestic tungsten light's 'warmth' suggests a welcome in this house. The photographer has intentionally done nothing to 'correct' the colour towards white.

**Photographer:** Jean Schweitzer.

**Technical summary:** Olympus E20, 1/8th sec at f2.2, ISO 80. Contrast adjusted and cropped in Photoshop.

# Incandescent lamps

The word 'incandescent' simply means glowing. As we saw in the first chapter, the source of our light is energy radiating from heated objects. In the case of the common household light bulb, this is a tungsten metal filament in an inert low-pressure gas atmosphere inside a glass envelope. In some 'living' museums, you may find carbon filament lamps in use; these were the forerunners of the modern metal filament bulb. Made from a carbonized bamboo, they give off a most attractive rich light and can be interesting photographic subjects in their own right.

As with candlelight, over-correcting the light from tungsten bulbs – to show a pure white in the colour print or digital file – is not correct. Though our brains compensate for the very yellow quality of their light, we associate household light with some yellow warmth and expect to see that in images of domestic interiors. Some photographers completely ignore the idea of colour balancing to the colour quality of incandescent light and do not attempt to correct its very yellow look on daylight film. Nan Goldin is one such photographer; in fact, one commentator used the phrase 'incandescently tawdry' in describing her work, possibly unconsciously connecting this aesthetic comment with the actual technical realisation and limitations.

Simple reading lamps and cheap spotlights using tungsten bulbs can be used very successfully for tabletop photography with a range of card and aluminium foil as miniature bounces. Some published professional quality flower images have been created using such simple equipment; it is more often attention to detail and aesthetic judgement that creates a beautiful image, not the use of expensive equipment.

**Photofloods** exist as a halfway point between domestic lighting and studio tungsten, though there are a handful of companies (Interfit and Stellar) producing professional studio fittings for these bulbs. Overrun photoflood bulbs produce a bright, whiter light than studio tungsten lamps and can be used in domestic light fittings (but see note below). They produce light at 3400K rather than the more yellow 3200K of studio tungstens. Both 275-watt and 500-watt (P1 and P2) bulbs will draw too much current to be safely switched through domestic light fittings. Some photographers get an electrician to produce a simple circuit board where two lamps can be run dimly in series for setting up and then run in parallel for full output. This also extends the life of the bulb which will be only 8–10 hours at best.

Note: Modern energy-saving light bulbs that fit into domestic light fittings do not have the same colour temperature as the tungsten/incandescent bulbs they replace as they operate on the same principle as the fluorescent light. If in doubt, check what is in the fitting or take a custom white balance reading.

**photoflood** tungsten filament (incandescent) lamp running at higher voltage than normal (overrun), which means a short life, colour temperature either 3200K or 3400K

### Nightmare (right)

The eerie green of uncorrected fluorescent light adds an element of alienation and edginess to this scene.

**Photographer:** Karl Fakhreddine.

**Technical summary:** Canon 1DS Mark II, Canon EF 16–35mm f/2.8L at 16mm, 1/30 sec at f2.8, ISO 1600, Custom white balance. Two assistants stopped traffic for the shoot in a tunnel below a shopping centre.

## Fluorescent light

Fluorescent light can pose a big problem for the photographer. It does not produce a continuous spectrum of colours but is a mixture of spikes of quite distinct colours, usually an unpleasant combination of green and orange/magenta light (with distinct spikes at 430, 550 and 610nm in cheap tubes). Not only that, but it flickers.

A fluorescent strip light is a partially evacuated glass tube with a small amount of mercury present. An electric current is passed through the tube, which causes the mercury vapour to emit strongly ultraviolet light – just like mercury street lighting. However, the inside of the strip light tube is coated with phosphors – materials that fluoresce – which absorb the UV light and give out visible light. The precise colour mix of light from a fluorescent strip light depends on the exact recipe for the phosphors. Different mixtures of the chemicals give different colour qualities of light that vary from manufacturer to manufacturer, change throughout the age of the light and depend on the cost and application of the strip light in question.

Digital photographers wanting to white balance to a fluorescent light source will usually have two or more preset values for fluorescent light. These will cover common fluorescent tubes as used in warehousing, to the so-called 'cool white', 'warm whites' and 'natural sunshine' (high colour rendition) lights used in offices and retail settings. The film photographer is less well-off, having to use an FL-D (fluorescent to daylight) filter that will often make only an approximate correction. The light quality may still have that distinctive look of strip lighting in the final print.

Lightboxes for viewing transparencies and negatives are a useful source of light for tabletop photography. These are invariably fluorescent light sources but the best will be daylight balanced. For small objects, they offer a large diffuse, continuous light source that is easy to position. For overhead lighting, it is sometimes easier to prop a lightbox on a couple of bricks than manoeuvre a big softbox with its counterbalanced boom and studio stand.

High quality fluorescent panel lamps are available for studio use. They use electronic ballasts that suppress the flicker seen with cheap fittings. Available with tungsten or daylight colour balance, they produce a colour consistent output over a long lamp life of around 10,000 hours.

## Street lighting

Like the familiar fluorescent strip light, street lighting is of the metal discharge type – usually mercury or sodium vapour – giving a distinct violet/blue and yellow light respectively. High output metal discharge lamps of this type are often used at sports stadiums. There are no specific filters to correct for this light, though digital photographers can use custom white balance or use RAW file capture and select colour temperature later. Film photographers will find a strong green cast in their images taken with mercury vapour lighting.

An attraction of street lighting is its evocative quality, part of which is the limited palette of colours and high contrast, to which you may decide black-and-white film is best suited. Street lamps are an unusually positioned light source – directly above on lamp standards – giving the unusual effect of shadows that look like noonday shadows cast from above, but which are seen against the dark. Because they are designed to shine downward only, with the right atmospheric conditions of fog or mist, streetlights create cones of light beneath them with patches of darkness between the lights.

Another most attractive and constantly varied light source in the street is that from shop windows. Their whole purpose is to attract passers-by and they often contain subjects worth photographing in their own right, lit as they are by professionals. The light from a row of lit shops is strong side lighting and can create exciting effects in night portraits.

The best street lighting of all are seasonal festival lights, especially in winter when snow or wet streets reflect the lights, which are usually made from tiny coloured bulbs. Out of focus effects are especially attractive. The light, and the weather, will give an added glow to complexions. Winter markets and streets are a rich hunting ground. Where tungsten bulbs are hung, they are usually fed from a generator and glow with a richer yellow than their indoor counterparts.

Original

Adjusted

### Dahlia by streetlight (above)

The harsh yellow of street lighting has been adjusted to leave a delicate colouration in this single dahlia flower, which was lit by a street lamp outside the window and photographed in the middle of the night.

**Photographer:** David Präkel.

**Technical summary:** Nikon D100, 60mm Micro-Nikkor AF-D, 30 sec at f/10 ISO 200, light from sodium vapour street lamp only. White balance shifted to 'correct' for yellow cast in Adobe Camera Raw.

**Starburst (above)**

The rich orange yellow glow of streetlights on the M62 motorway near Leeds makes a dramatic image. Small aperture gives starburst effect from the shape of lens iris.

**Photographer:** Adrian Wilson.

**Technical summary:** Canon 10D, Canon 80–200 f/2.8 L at 200mm, f/22.

## Neon light

Neon light is another form of discharge lamp, but it uses special gases in a clear tube to create strongly coloured light rather than attempting to produce a balanced white output. Not surprisingly, one of the first gases used was neon, which gave the gas discharge a characteristic red glow. Nowadays, a range of well over 100 distinct colours can be produced with a mixture of gases that includes argon, neon and carbon dioxide, combined in proportion with mercury vapour and fluorescent phosphors. Neon sign-makers show a catalogue of 'whites' ranging from blue-white 8300K to yellow-white 2400K, along with blues, greens, 'golds', reds and violets.

As it is the colours that the photographer is looking to capture, there is no colour correction or balancing applied. The best results are obtained using daylight saturated warm film or by increasing the digital saturation slightly in-camera with either a custom, automatic or daylight white balance. The best time to photograph neon has to be after recent rain. In this way, you can 'double your money' as the bright neon light sources are reflected on wet surfaces.

The necessary long exposures suggest creative opportunities, such as blurring the image for part of the exposure only or producing intentional camera shake. Focusing and de-focusing during exposure gives attractive halos of blur depending on the relative time the image was in or out of focus during the exposure. Alternatively, a zoom lens can be zoomed during the exposure, but the camera should be kept steady to simplify the effect. If the neon signs take up only part of a very dark frame, a double exposure can be used to duplicate the bright sign into the dark, effectively unexposed, part of the frame on the second exposure. (There are only a couple of professional digital cameras that allow true double exposure in-camera.)

### Water colours (left)

A long exposure and reflections in the wet pavement make the most of colourful sources of light from this fun fair in Alkmaar, in the Netherlands.

**Photographer:** Wilson Tsoi.

**Technical summary:** Canon PowerShot A80 (4MPx), 7.8–23.4mm f/2.8–4.9 (built-in lens), 4 sec at f/8, ISO 50 on tabletop tripod triggered with self-timer in rain at night.

## Photography in low light

| Subject | Exposure Value (ISO 100) |
| --- | --- |
| Moonlit landscapes (moon not in picture) | EV3–4 |
| Candlelight | EV4 |
| Christmas tree lights indoors | EV4 |
| Floodlit buildings at night | EV4 |
| Traffic (light patterns from moving vehicles) | EV4* |
| Fairgrounds | EV4–EV6 |
| Room interiors | EV5 |
| Subject lit by blazing bonfire | EV5 |
| Museum/art gallery interior (well-lit) | EV5 |
| Room interiors (white walls, bright lights) | EV6 |
| Christmas tree lights outdoors in snow | EV7 |
| Brightly lit city streets | EV7 |
| Theatre/circus (floodlit–spotlit) | EV7–EV9 |
| Shop windows | EV8 |
| Bonfire | EV8 |
| Floodlit sports field | EV8 |
| Skyline at sunset | EV10 |
| Moon (close-up with telephoto) | EV13 |
| Fireworks | use B at f/16** |
| Lightning | use B at f/8** |

\* but use small aperture
\*\*leave shutter open but cover lens between flashes/bursts

# Gig photography

Digital cameras have made photography during concerts very popular. To get the best quality results you need to be close, which means negotiating access; that advice is as important as anything technical. The problems are low and varying light levels. The solution is to use a high sensitivity (for acceptable noise) or high-speed film with fast lenses used wide open. Shutter speeds will rule out casual hand-holding especially if you need to use a telephoto, so good camera support is essential – a tripod will almost certainly not be permitted. Auto focus may not work well so switch to manual and remember to focus carefully as there will be limited depth-of-field with a telephoto at maximum aperture. Practice focusing on two or three places while the lights are up. Finally, learn to squeeze the shutter between breaths. Check digital exposures on the histogram. If you cannot get steady shots, try to capture mood and movement instead.

## Robert Plant in concert (facing opposite)

Anticipating the moment, and careful camera position to put the lights into place as part of the overall composition, are the keys to successful gig pictures.

**Photographer:** Sam Henderson.

**Technical summary:** Nikon D100, Nikon 80–200mm f/2.8 AF-D at 145mm, 1/80 at f/5.0 ISO 800, custom colour profile.

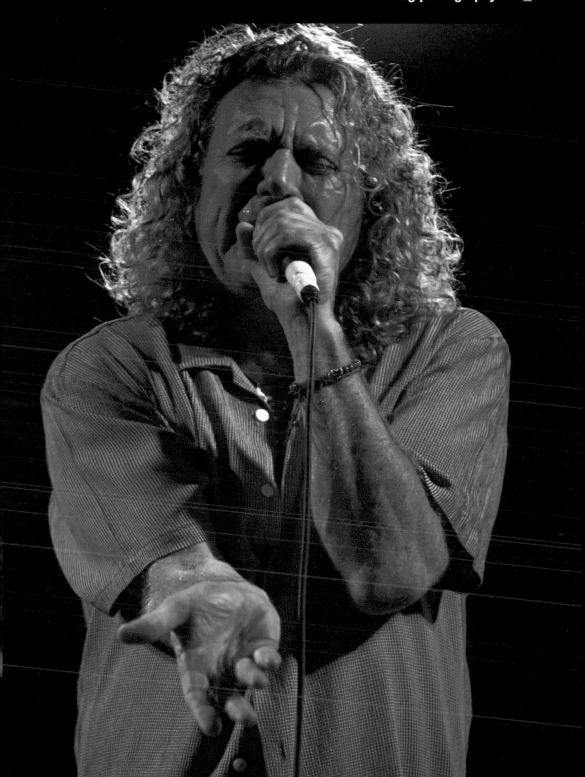

Photographic light is light that is generated specifically for the purposes of photography – it is not natural light and it is not light produced for other purposes (street lights, for instance).

The home of photographic light is the studio, where light is divided up into two main categories – continuous and flash. Continuous light is the easier to work with as you can immediately see its effect. Adding lights and controlling reflections is easy. The drawbacks to continuous lighting are either its low power or the heat it produces.

Studio flash is more powerful and cooler running than tungsten lighting, which is still probably the most commonly encountered continuous lighting system. Flash has one downside – what is seen in the studio by the photographer is not quite what the camera 'sees' at the moment of exposure. You need experience to judge just how the final image will look from the effect seen under the modelling lights. However, digital capture does make this process much easier. Film photographers may test on Polaroid 'instant' material to see how the exact lighting balance looks and to avoid hotspots or unwanted reflections before committing to the final film image.

Flash is the most powerful and compact light source available. Even tiny battery-power flashguns in compact cameras are sufficiently capable of lighting a fair-sized group of people. Flash can be used out of the studio on location, but with smaller flashguns and on-camera flash you may have no idea how the image will look until the film is developed or reviewed on a digital camera back. This can be a frustrating hindrance. Flash photography can all too often have the 'look of flash', with white foreground objects and dark backgrounds; using diffusers or bouncing flash off adjacent surfaces helps. Modern wireless controlled battery flash units can now be dotted around to illuminate corners and backgrounds without the need for wires or mains power. For photographers who need the power of studio flash on location there are mains rechargeable battery generators.

## 'Lighting is more complex than one thinks.'

*Horst P Horst (studio fashion photographer and portraitist)*

### Beauty 25 (facing opposite)

Once mastered, light created in the studio and controlled by the photographer gives rise to the most arresting images.

**Photographer:** Stéphane Bourson.

**Technical summary:** Canon 20D, Canon 100mm f/2.8 Macro EF, 1/200 sec at f/29, ISO 100. Single flashhead with beauty dish above the model on a boom. Make-up: Olivia Keuster.

## Continuous light

**Continuous light** is lighting that is on all the time. What you see in front of you in the studio is what you photograph. For this reason alone, it is often favoured by those starting out. Nor do you need a special flash meter, as any ambient light meter will work. Continuous light sources fall into three categories: **Tungsten** lights, metal discharge lamps and fluorescent panels. Tungsten lamps are rated by the wattage of their bulbs and are available in a range of powers from 500–2000 **watt**. Remember that some of this energy is converted into heat as well as light, so tungsten studios can be hot and smelly places in which to work! This is the lighting that tungsten balanced film was created for. If daylight balanced film is used it must be exposed through an 80B filter, or alternatively blue gels can be used over the lights. Digital cameras offer preset tungsten white balance, though a custom measurement is preferable as the colour output changes as tungsten bulbs age. Black-and-white film will be slightly underexposed by the yellow tungsten studio lights, so compensation should be made for this.

With their long history of manufacture, some brand names are synonymous with the lamp type – you would commonly hear a tungsten spot lamp referred to as an 'ARRI'. As perhaps the oldest form of photographic lighting, tungsten offers the full range of **spots** and floods, with light shapers such as 'barn doors' and beauty dish reflectors now also used on **flash heads**. Though tungsten lamps look bright, it is sometimes hard to get sufficient depth-of-field with slower films/low ISO sensitivity. Heat build-up also makes it difficult both to adjust the lights and to use gels. Though cheap to buy, the running costs of tungsten can be high.

Studio fluorescent lights balanced for daylight use are a more recent introduction, though they have been used successfully in colour television studios for years. Tubes are arranged in banks to create a soft, diffuse light quality similar to that from a **softbox**. The least expensive units – though supposedly daylight balanced – give an odd light quality (see pages 78–9 on fluorescent lights). Professional fluorescent lamps are bright, but many fluorescent flat panels that are sold as suitable for still photography are prohibitively limited in output, which restricts their use to still life and wide apertures.

Metal discharge or high intensity discharge (**HID**) lights (including **HMI** and **HQI**) are named after the mercury used in the bulbs. They are used widely for lighting film sets in the motion picture industry. They run at daylight colour temperature, are flicker free (better than fluorescents for digital work), cooler than tungsten lamps and produce a good quantity of light. Their popularity is growing with still life and room interior photographers because of their easily mixed colour balance and controllable output.

Fluorescent panels –
Photon Beard Highlight.

Tungsten lamp.

**continuous light** any light source that shines without break or interruption – usually used for tungsten lights to distinguish them from flash

**flash head** usually a combined flash tube, modelling light and cooling fan that takes its power from a separate battery pack or generator in contrast to an integrated monobloc/monolight

**HID lighting** generic term for High Intensity Discharge lighting, including HMI and HQI lamps

**HMI lamp (metal halide)** type of HID lamp; rapidly pulsed light giving effectively continuous output running at daylight colour temperature (5600K), (from hydrargyrum (mercury) medium-arc iodide)

**HQI lamp (metal iodide)** type of HID lamp (from hydrargyrum (mercury) quartz iodide)

**softbox** box or frame covered with translucent (light diffusing) material, used over flash head to create a soft light, available in various sizes

**spot** (mini spot and zoom spot) spotlight; small spotlight; spotlight with adjustable reflector

**tungsten** incandescent (glowing) electric light bulb with filament of tungsten metal; hot and inefficient, but unlike flash its effect can be seen and judged. Used as modelling lamps in flash heads

**watt** SI (Système International d'Unités – International System of Units) unit of power – the rate at which work is done – one joule of work per second of time. Watt rating of tungsten lamp indicates light output

# Flash

A modern flashgun is a most versatile light source; powerful yet lightweight. Their light can be bounced or diffused just like any other light and electronic flash is balanced at daylight colour temperature. There are disadvantages – the exposure is only correct for a set distance, which can produce dark backgrounds and overexposed foregrounds. There are pronounced bright reflections in shiny surfaces with flash and this cannot be easily previewed, although some modern flashguns have a low power modelling 'rapid fire' setting that shows (just about) where reflections will be.

Accessory flashguns are more powerful and can be used both automatically and manually. Communication is through the camera '**hot shoe**', which has electrical contacts to fire the flash. In many cases, the camera electronics will interact with the flashgun to fire a metering pre-flash and also use flash for autofocus illumination in the dark. To reduce red-eye and give some modelling light, an extension lead is used between the flashgun and camera to move the flash away from the lens. Many photographers use bounce flash or diffusers to improve the light quality, but these techniques can sap power. So-called 'professional' flashguns are high powered with rapid recycling and many use a separate **battery pack**. **Slave flashes** are independent units that fire when illuminated by the flash from the main unit. They are handy portable sources of light to illuminate small, shadowed areas or to give background effects.

Automatic flashguns are still commonly used with medium format cameras without light meters. These guns use a flash calculator (a scale or dial) where aperture and film speed can be related to the flash unit's guide number. A sensor in the flashgun quenches the output from the flashgun when the subject has received enough light. However, just as with reflected light meters, automatic flashguns give problems of under- and overexposure with very light or very dark subjects. You can compensate manually; if the flashgun says f/11, using f/16 on the lens will effectively halve the apparent power, using f/8 will double it. Dedicated flashguns do not allow for this as they set the aperture from the camera's electronics. With a film camera you can cheat by overriding the DX film speed: setting ISO 50 instead of ISO 100, for example, will force the flash unit to give one more stop power, setting ISO 200 will give one stop less.

| | | |
|---|---|---|
| Typical guide number 6–12 m/ISO 100. | Typical guide number 10–15 m/ISO 100. | Typical guide number 15–50 m/ISO 100. |

A built-in flash on a compact digital camera is close to the lens axis and red-eye will result without a red-eye reducing pre-flash. Low power useful for daylight fill.

A pop-up flash moves flash to some degree off lens axis, but red-eye may still result. Output can be adjusted to better balance flash to ambient light .

Auxiliary flash 'talks' to camera through a hot shoe. Flash is away from lens axis and can be rotated, diffused or bounced. Used off-camera with lead or wireless flash.

## Flash – guide numbers

There are three key specifications for any flashgun – **guide number** (a measure of flash power for a given film speed), recycling time (the speed to recharge between flashes) and coverage (the angle that the flash beam covers).

Exposure calculation with a manual flashgun – or flashbulb for that matter – is done using the manufacturer supplied 'guide number'. This single number relates lens aperture and distance to the subject for a particular film speed or ISO sensitivity and is an indication of the effect a flashgun will have under standard conditions. Guide numbers are given for a particular film/ISO sensitivity, usually ISO 100, and for flash-to-subject distance in either feet or metres. Don't confuse the two! A guide number of 10 in metres equals a guide number of 33 in feet (to convert GN metres to feet, multiply by 3.3; to convert feet to metres, multiply by 0.3).

**Guide number = aperture x distance**
**To work out the aperture**: measure the distance to the subject (use your lens scale). Divide the guide number by this distance to get the f-stop. Guide number of 45 (GN) Flash to subject distance is 8m (FD) Aperture is unknown (f) f = GN/FD 45/8 = f/5.6

**To work out the flash distance**: divide the guide number by working aperture to get the flash to subject distance. Guide number of 45 (GN) Flash to subject distance is unknown (FD) Aperture is f/11 (f) FD = GN/f 45/11 = about 4m

**To check the guide number of an unknown flash unit**: set the unit to manual and the flash meter for ISO 100, place the flash 1 metre distant and take a flash reading. The aperture is the guide number.

The ideal is to use a flash meter or a light meter that can measure flash (flash output is too brief to register on an ambient light meter). A test flash is fired and the meter will give an appropriate aperture for the film/digital sensitivity in use. The best purchase after your first flash unit is a professional quality flash meter rather than a second flash unit!

**battery pack** power supply for flash heads that is charged by mains electricity but which works independently and can be used in the field
**guide number** a number used to describe the maximum coverage distance of a flash unit for a given lens aperture and film speed/sensitivity
**hot shoe** camera accessory shoe with electrical (hot) contacts for triggering flash when shutter is released
**slave flash** independently powered flashgun that is triggered by flash of main unit, often of lower power and used as effects light

## Flash synchronisation

Sometimes called 'sync' or 'synchro', **flash synchronisation** is the correct timing of the flash to illuminate the whole film frame or digital sensor. This is not so much of an issue with **leaf shutters** in medium format and large format camera lenses as they always open to expose the whole area. However, 35mm and digital SLRs and cameras with **focal plane shutters** do not. Their travelling curtain shutters must be fully open so as not to produce an unexposed bar on the image. Therefore the first curtain must have cleared the frame and the second not yet begun to travel when the flash fires. This means a slow-ish shutter speed (1/60 on older cameras, but 1/180 or 1/250 on more modern models). Slow sync speeds can limit fill-flash control with some cameras. Older cameras and lenses will have X and M settings next to the flash sync socket: X is for electronic flash; M is for flashbulbs.

Cameras can fire flashguns through a PC flash sync socket on the camera body or lens mount, through a 'hot shoe' accessory connector with electrical contact, or by means of an infrared or radio pulse from a flash sync transmitter fitted in the camera hot shoe. Plugs and cable are usually reliable if they have not been abused but they do create clutter. Infrared requires a line of sight to the flashguns to be triggered, while wireless solutions can be expensive.

The brief flash of light from an electric spark in the flash tube of a flashgun is typically of a much shorter duration than the shutter speed used on the camera. Depending on the size of the unit, the flash duration will be between 1/2000 and 1/10,000th second – short enough to freeze motion. Classic images from the early years of electronic flash photography show frozen drops of water, frogs caught mid-leap and apples, balloons or playing cards pierced by bullets (those interested should look at images by Harold Edgerton). There is still a fascination in 'seeing the un-seeable', of having flash freeze a fraction of a second for our repeated observation.

**flash synchronisation** timing brief burst of light from flashgun to appear between the opening and closing of the camera shutter

**focal plane shutter** camera shutter that operates close to the film/sensor in the plane of focus of the lens – common in digital SLRs and 35mm cameras. Comprises adjustable slit between two 'curtains' that travels to expose film/sensor to light. To synchronise properly with flash, slit must be wide enough to expose whole film/sensor, this limits maximum shutter speed at which flash synchronisation can occur

**leaf shutter** shutter mechanism usually found in between lens elements; because of nature of its operation, flash synchronisation can occur at any shutter speed. Usually found in lenses for medium and large format cameras

**sync** to time the moment a flash is fired to coincide with the correct opening of the camera shutter for a proper exposure

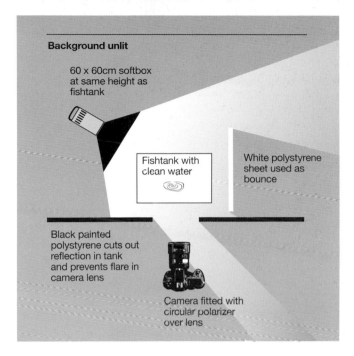

Lighting setup for 'A splash of lime'.

**Background unlit**

60 x 60cm softbox
at same height as
fishtank

Fishtank with
clean water

White polystyrene
sheet used as
bounce

Black painted
polystyrene cuts out
reflection in tank
and prevents flare in
camera lens

Camera fitted with
circular polarizer
over lens

### A splash of lime (right)

To get a workable depth-of-field the
softbox was moved close to the subject
and metered at f/8. Side lighting was
used to show texture in the fruit slice.
This was balanced with a reflector to the
right. The background colour was
unimportant as, being unlit, it would
appear black. Care was taken to avoid
light spilling on to the background or on
to the camera lens, which was flagged
with polystyrene boards. A circular
polarizing filter on the lens helped
control glare and reflections. The slice of
lime was dropped into the water over
200 times to achieve this perfectly frozen
splash. Though the shutter speed was
only 1/125th second, the flash duration
would be about 1/2000th second;
ambient light was excluded.

**Photographer:** Anton Heiberg.

**Technical summary:** Pentax *ist D, 35–70mm
zoom with C-Pol filter, ISO 200, 1/125 at f/8.

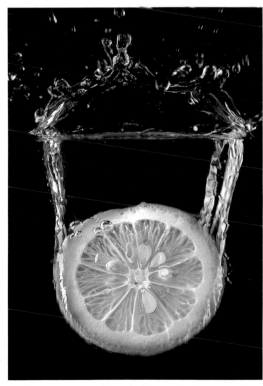

### First and second curtain sync

It is possible to synchronise the flash burst either at the beginning of the exposure or at the end. When the flash goes off first, it is described as first or front curtain sync (after the shutter curtains). This kind of exposure gives a crisp image followed by the blurred exposure. Using this technique in the dark with a moving vehicle will produce an unnatural image with what appears to be a stationary vehicle with speed lines coming from the front. Synchronising at the end of the exposure, so-called second or rear curtain sync, will give the expected result of a vehicle trailing blurred lines.

Whether front or rear sync, it is possible to use slow flash synchronisation to great effect to emphasise movement without losing subject clarity. It is common for photographers to intentionally move the camera in a circle or jog it from side to side during a slow sync picture to ensure the ambient light component of the picture is aesthetically blurred. The flash will then superimpose a crisp image of the subject into the blurred background. The exposure guidelines for balancing ambient and flash apply as slow sync can be considered an extreme form of fill flash (see pages 106–7).

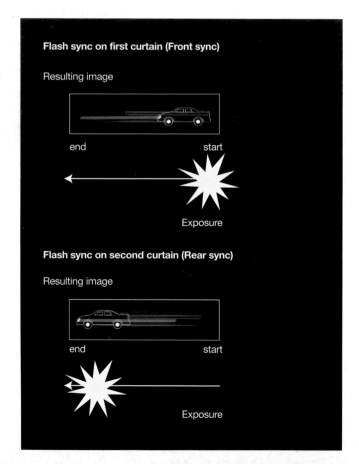

**Flash sync on first curtain (Front sync)**

Resulting image

end      start

Exposure

**Flash sync on second curtain (Rear sync)**

Resulting image

end      start

Exposure

**Newry wheelers (facing opposite)**

Slow speed front curtain synchronisation with some camera panning creates a good combination of motion blur and a crisp well-lit image that captures the drama of competition in a three-day road race.

**Photographer:** Phil McCann.

**Technical summary:** Canon EOS 300D, Canon 18–55mm, 1/60 sec a f/8, ISO 100, Canon Speedlite 420EX.

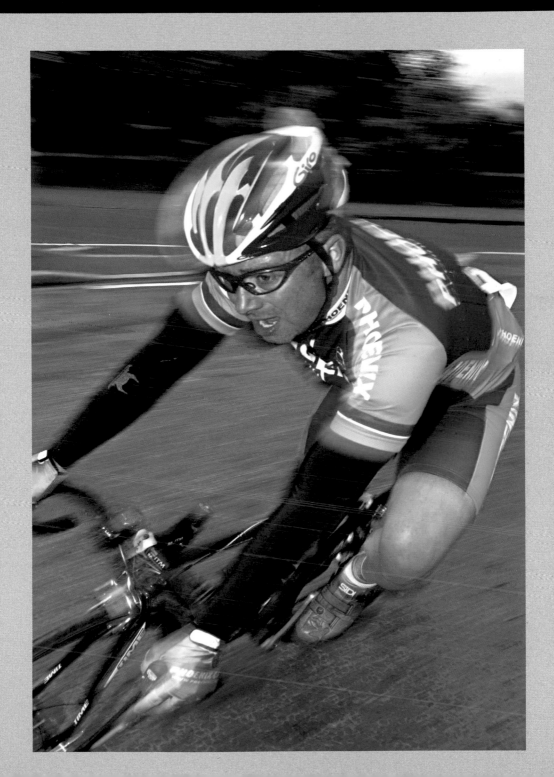

## On-camera flash

Pop-up or on-camera flashguns are convenient but always of low power. They drain the main camera batteries, usually give red-eye or unflatteringly flat lighting, and are best used for fill flash in daylight. Flash coverage is not always that great and if you are using a wide-angle zoom first, make certain you don't go wider than the angle of coverage of the flashgun unless you want a central hotspot of light. The large 'petal' lens hoods supplied with many wider zooms can cast large half-moon shadows in the bottom of pictures taken with on-camera flash. To check for both light fall-off and unwanted shadows try photographing a featureless wall square-on at various focal lengths.

On-camera flash will produce the familiar 'red-eye' effect when the flashgun is close to the lens axis (which it is with most compact cameras with built-in flash). Light from the flashgun enters the eye and illuminates the blood in the retina, which is then photographed. 'Red-eye reduction' is offered on most cameras with pop-up flash. This is usually a pre-flash (or flashes) that closes the subject's iris, but also tends to make them squint in the picture. On-camera flash also produces a very flat frontal light, giving little or no modelling effect.

Despite these negative comments, on-camera flash is tremendously useful as a fill-in light source to add some light to shadow areas and to provide **fill light** on backlit subjects. On-camera flash will lift the look of any backlit portrait but it is worth experimenting with the flash power to get the light balance you prefer – do not rely on the manufacturer's default power setting. (See pages 106–7 on Fill flash and Balancing light sources for more information.)

One time-honoured method for reducing the harsh frontal quality of on-camera flash was to drape a handkerchief over the flash tube. This not only reduced the flash output, but also gave the light a more diffuse quality. Many accessory flashguns now come with white plastic diffuser boxes that produce a more flattering light. Accessory manufacturers Sto-Fen and LumiQuest® offer a range of after-market diffusers and bounces.

Early adopters of electronic flash found it gave a better light when bounced off a nearby ceiling (or wall) with the flash head angled so the light would reflect off that surface. Because the light had further to travel and was not perfectly reflected, some compensation had to be made in the flashgun output. Modern integrated flashgun/camera metering systems do away with the need to use rule-of-thumb calculations for bounce flash. The most natural light, free of harsh shadows and unpleasant hotspots or highlights, is flash that is both bounced and diffused. Luckily, digital capture gives photographers the opportunity to experiment with flash lighting arrangements at no cost.

**fill light** light from a reflector of a separate lamp or flash head used to illuminate the shadows cast by key (main) light and so reduce the lighting ratio

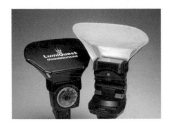

LumiQuest Midibouncer mounted on a Sunpak accessory flashgun – front and back views.

### Dribble (below)
On-camera flash – in this case an accessory flashgun – illuminates only the centre of the image when a wide-angle lens is fitted to the camera. The animal's muzzle being closest to the flash is also more brightly lit. The limitations of on-camera flash used to the photographer's advantage.

**Photographer:** Ian Taylor.

**Technical summary:** Canon EOS 10D, Canon EF 24–70L zoom, ISO 200, 1/125 sec at f/5, with Canon 550 EX Speedlight.

### Studio flash

The flashguns used in studios are more powerful versions of the familiar battery-powered flash units found on nearly all modern cameras. Studio flash is usually powered by mains electricity, though there are two distinct types of unit. The **monobloc** – or monolight, as it is known in the USA – is a compact unit with an integrated flash tube, modelling light, a cooling fan, power supply and independent control circuitry. These units are more commonly encountered in small to medium-sized studios. Bigger studios tend to use **generators** – or 'pack and heads' as they are known in the USA. Generators house the power supplies and control circuits for independent 'dumb' flash heads. They are described as being **symmetrical** or **asymmetrical generators** – a symmetrical unit delivers equal power to each flash head that is plugged in; an asymmetrical unit can deliver different power to each of two, three or four outputs. The flash heads connected to generators usually have integrated compact cooling fans to moderate the heat generated by the tungsten modelling lights.

**Profoto pack and heads**
Typical guide number 50–300 m/ISO 100.

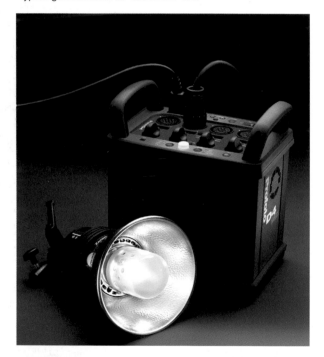

asymmetrical generator power supply that can feed two or more flash heads of different power outputs
generator power unit for two or more flash heads (known as pack and heads in USA)
monobloc studio flash unit with independent built-in power source (known as monolight in USA)
symmetrical generator power unit for two or more flash heads that only delivers similar powers to each head

Generators offer the convenience of being able to control flash output from one location; you can also check the charge status of each flash head from the generator. Monoblocs usually feature an audible beep to 'announce' when they are recharged, as you cannot always see the recharge lamp from all locations in the studio.

Be warned that studio flash may not operate as expected when you turn the power down. Electrical energy for a flash is stored internally in a capacitor circuit, which is fully discharged for each flash fired. For example, if you are working at a three-quarter power setting and choose to reduce the output to half power, the unit will have recharged sufficiently to fire at three-quarter power and will fire next time with that output, despite now being set to half power. Subsequent flashes will be at the lower power setting. You must remember to dump the excess power if you turn the unit down or the next image will be unintentionally overexposed.

Guide numbers are not commonly quoted for studio flash heads as the fitted reflector can have a great effect on output. Studio flash units are instead rated in **joules** or **watt/seconds** but even this can make comparisons difficult, as one 2000 w/s unit may be less efficient in converting that energy to light than a 2000 w/s unit of a different manufacture. Some manufacturers will rate their flash head in the rather confusing watt/seconds per minute – this takes into account the recycling (recharging) time of the unit and rates how many maximum power flashes the unit can deliver in the space of one minute. This may seem a rather arbitrary way of claiming high power outputs, but it has a practical aspect as many photographers will use **multiple flashes** for one exposure to achieve enough light to permit the use of small apertures. Professional flash meters will accumulatively measure multiple flashes for this very reason.

**joule** SI (Système International d'Unités – International System of Units) unit of work or energy
**multiple flash** build up exposure with series of flashes, possibly to be able to use a smaller lens aperture
**watt/second** unit of energy equal to one joule, often used to describe studio flash units, but misleading as it does not take into account efficiency of unit in producing light

## Modelling lamps

It is difficult, if not impossible, to judge what a set will look like lit by flash. This is why flash heads are usually equipped with **modelling lamps**. These lamps – placed inside the ring of the flash tube – are either tungsten or tungsten halogen bulbs giving a continuous light that will look the same as the flash. They will also be affected by any light shapers used on the flash head in just the same way as the light from the flash tube. Flash lighting is judged using this continuous light. Proportional modelling lights can be run at half or full power, but will 'track' the flash power that has been set for each flash head and give some indication of how the final lighting arrangement will look. There is some degree of interpretation and experience required in their use, as they do not have the same crisp power that flash gives to the final exposure. However, their use is vital when it comes to seeing hotspots and unwanted reflections.

Infrared handsets are available with some flash systems, giving remote control over multiple flash heads up to 10 metres away. This enables the photographer remotely to adjust power levels and modelling lamp settings, as well as programme bracketing sequences. Some generators are now equipped with USB connectors that give computer control for lighting setup.

Tungsten modelling lamp at the centre of the flash tube of a Bowens Esprit monobloc.

Independent modelling lamp and flash power controls (5-stops range) on a Bowens Esprit monobloc; charge indicator lamp and flash dump button in between.

**modelling lamp** continuous light lamp usually set at the centre of the flash tube in a studio flash head to show effect of the light from flash itself, does not contribute to exposure, may be adjustable in proportion to flash output

Main controls on a Bowens Esprit monobloc.

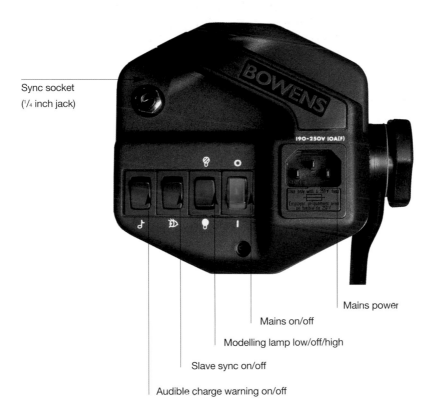

Sync socket
('/₄ inch jack)

Mains power

Mains on/off

Modelling lamp low/off/high

Slave sync on/off

Audible charge warning on/off

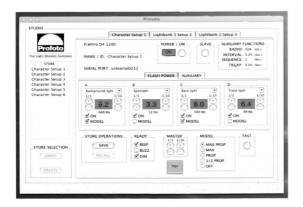

Increasingly, flash will be controlled by computer. This is a sample Profoto Character setup for four flash heads.

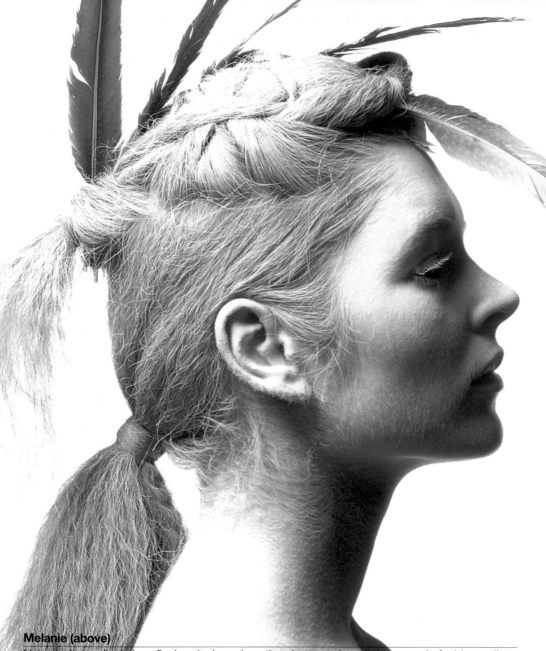

**Melanie (above)**
Using only small wireless flash units has given the photographer all the control of a big studio setup – if not its ultimate power – but with greater flexibility.

**Photographer:** Frank Wartenberg.

**Technical summary:** Nikon D1X with five wirelessly linked Nikon 5B–80DX Speedlites – three through a diffuser above and to the right of the model; one bounced on a reflector below her face and one aimed to bleach out the background.

## Wireless flash

One of the most exciting developments of flash photography in recent years has been so-called 'wireless' flash. In an attempt to reduce cable clutter in the studio, manufacturers long ago started linking flash units through flash-activated infrared links rather than the festoons of sync cables that had previously been required. This is mere flash activation, as there is no passing of information between the flash heads. It is just a 'you flash when I flash' system.

Wireless flash takes this idea one major step forward by using a designated main flash head to communicate settings to the other units in a series of short pre-flashes. These do not contribute to the exposure. Modern accessory flashguns from principal camera manufacturers now offer wireless control of flash with up to three channels of communication between the camera and groups of independent flashguns. The latest semi-professional digital SLR camera bodies also have the same wireless flash control software on-board, using the camera's pop-up flash to communicate with the remote flashguns. Top-of-the-range professional cameras do not feature wireless flash control as they do not have pop-up flashguns and must therefore rely on an accessory commander flashgun to control the wireless slaves.

The commander flashgun or camera will group the flashguns into three or four 'channels'. Members of these channels fire together and their output can be controlled to give specific lighting ratios. A photographer can take a bag of battery-powered accessory flashguns on location and have a system that is almost as controllable as full studio lighting – without the modelling lights, of course.

Wireless flash is designed to work with the slave flashes up to about 10 metres distant from the commander. The wireless flash systems from camera manufacturers are not designed for use in a concert hall or sports stadium, where specialist equipment such as the Quantum FreeXWire system would need to be employed. However, wireless flash can work wherever the slave units can see light from the commander. This allows photographers to use slave units outside windows where long cable runs or lack of access would normally prevent their use.

Nikon Wireless flash commander with three wireless flash units mounted for use as a macro light. They can be detached and used as free-standing flash heads with independent or group control up to 4m (13ft) away from camera.

### Ring flash

The **ring flash** is either a circular flash tube or a circle of segmented flash tubes that fit around the lens. It was originally designed for scientific close-up photography to give shadow-less images, but it has been adopted by fashion photographers to give flat lighting that leaves a tell-tale doughnut **catchlight** in the model's eyes. Because of the distinctive look it produces, its use in fashion photography is beginning to fall away. However, it remains a powerful tool for the macro or close-up wildlife and commercial stills photographer.

Studio ring flashes are often much bigger single-tubed units rather than the segmented tubes used in the so-called macro light for 35mm and digital SLR systems. Segmented ring flashes have one advantage in being able to produce some degree of modelling as well as producing direct frontal light. This is because the photographer has some element of control over the output of the individual flash tube segments of the ring. These are usually reduced to two curved left and right segments in the macro flashguns sold for 35mm and D-SLR cameras, which have individual power output adjustment.

A professional ring flash unit can deliver up to 3000 w/s of light and has fitments for the larger lenses of medium format cameras, as well as hard light reflectors and a diffuser.

Bowens ring flash with medium format camera.

**catchlight** bright reflection in the eyes of the subject in a portrait
**ring flash** circular flash unit that fits around the camera lens to give even, shadow free light. Some units made up of independently powered segments

## Lauren (above)

On-axis ring flash gives this characteristic shadow-free lighting and a distinctive doughnut-shaped catchlight in the eyes.

**Photographer:** Colin Demaine.

**Technical summary:** Nikon D70, Sigma 50mm Macro, ISO 200 1/100 sec at f/8 with Sunpak ring flash. General retouching of blemishes using cloning and healing tools in Photoshop, overall skin appearance smoothed out, the eyes were given more life by painting colour into them.

## Catherine (above)

Fill flash balances the natural sunlight to perfection, adds hair accents and provides some rim lighting so that the model's green top stands out from the similarly coloured background.

**Photographer:** Rod Edwards.

**Technical summary:** Mamiya 645 Pro TL, Mamiya 150mm prime lens, Fuji Reala ISO 100 colour negative film (rated at EI 64 for greater shadow detail), 1/250 sec at f/5.6 with polarizer to cut down the light, enabling a wider aperture to be used for shallow depth of field. Fill flash from softbox mounted on stand using Elinchrom Ranger portable location battery pack and head. Fill flash gave 1:1 ratio with daylight. Blue grad effect was also added to sky with Photoshop after scanning.

### Fill flash

Flash can dominate an image even on a bright day, especially if the subject is close to the camera. When the flash power equals the ambient light, the ratio is said to be 1:1. A more natural look is achieved when the flash is one stop down (less bright) on the ambient light, which gives a 1:2 ratio. Even lower ratios of up to 1:4 are useful to add some fill into the shadows and bring down their colour temperature (warm them up). There are wedding photographers who always use a flashgun – even on bright days outdoors – simply to put a catchlight reflection in the subject's eyes. This will give life to a picture, even though the flash may be making little contribution to the overall exposure.

Some flashguns have flash power compensation and some cameras feature this in their built-in flashguns. The power can be dialled up or down – usually in half or third stop increments – to balance output to the subject. When set at 0EV (no compensation) many manufacturers' flashguns are too powerful and you might prefer the look of a lower power setting, especially for fill flash work.

### Balancing light sources

The idea of balancing different light sources can mean one of two things. First, balancing the intensity of two sources (usually daylight and flash) to get a combined effect favouring one or the other or, second, the need to choose an appropriate white balance when light sources with very different colour temperatures are featured in an image (see also pages 26–7). As electronic flash and daylight have very similar colour temperatures, they are more easily combined than tungsten light and daylight.

The technique described here as 'fill flash' is sometimes called 'syncro sun'. Calculating fill flash can be done manually if you are working with a manual camera and flashgun. For example: you are using a sensitivity of ISO 200 or a film of that speed and the flashgun calculator suggests f/8 as the appropriate aperture for your subject at 3 metres. Using a hand-held light meter, take a reading of the ambient light, which suggests, for instance, a shutter speed of 1/125 sec if the aperture is f/8. This would give a 1:1 ratio between the flash and ambient light. To achieve the preferred 1:2 ratio the flash power needs to be reduced by 1 stop. Closing the lens aperture down to f/11 underexposes the flash by 1 stop, but to compensate for the loss to the ambient light setting the shutter speed must now be set 1 stop slower at 1/60 sec. It is for the ability to balance out flash at a range of shutter speeds that professionals prefer the leaf shutters in medium format camera lenses to the focal plane shutters in 35mm and most D-SLR cameras. Focal plane shutters are limited to flash sync speeds of between 1/60 and 1/250 sec because the first curtain has to fully clear the film before the second curtain closes and this limits the fastest speeds at which synchronisation can happen.

## Flashbulbs

In the minds of many photographers, flashbulbs have been consigned to history, along with flash powder and photographers' top hats. They could not be more wrong. Though small flashbulbs can no longer compete with the convenience of the battery-powered electronic flashguns, there is still a specialist market for large flashbulbs because they can offer a light output that is unmatched by any other portable source.

The flashbulb is a glass envelope containing fine metal wire or foil (commonly magnesium or zirconium) that is made to burn in an oxygen-rich atmosphere. The bulb has a lacquer on it that prevents the glass envelope shattering when the contents burn – this may be coloured blue to balance the output of the bulb to daylight colour temperature. Large flashbulbs can be fired where there is no mains electricity and where even the battery packs of portable flash units could not be carried. Cavers use flashbulbs for the duration and power of their output, their low weight and ease of firing with a portable battery. The flash duration can be anything from 1/4000th second to a two second burn, depending on the design. Once fired, however, they will never flash again.

The individual perhaps most closely associated with the use of massive yet portable flashbulb equipment is O. Winston Link, the advertising photographer who captured the end of the American steam railroad – and the end of a way of life – in the 1950s. His night flash images of giant steam engines and drive-in movies remain popular as prints today. It is to grand subjects that the flashbulb is now best suited. Cave and underground photography have already been mentioned, but flashbulbs are also used whenever a very high light output is required for a short time, as in high-speed photography where a flood flashbulb can produce enough light to make exposures of 1/40000th second possible with special cameras.

Meggaflash PF300 flashbulb, medium intensity slow-peak flashbulb (life-size). Guide number approximately 165 (m/ISO 100), which puts this single bulb in the same light output category as a medium-sized studio flash head. Colour temperature is approximately 3800K.

## Minaret turn (above)

BC Rail's Minaret Turn sitting on the Sustut River Bridge in northern British Columbia, Canada – an extremely isolated location, 50 miles from the nearest road, so all equipment had to be brought in by rail. Photograph produced with the full co-operation of BC Rail.

**Photographer:** Dale Sanders.

**Technical summary:** Nikon F3HP 24mm lens, 30 seconds exposure at f/4, Fuji Provia 100F (RDPIII). 54 Meggaflash PF200 flashbulbs arranged in three foil-covered panels – a primary panel comprising 27 bulbs was placed at the river's edge left of the camera position, 250 feet from the bridge. A second panel with 9 bulbs was placed on the track 150 feet away from the nose of the lead locomotive; the third panel using 18 flashbulbs was behind the trees at the base of the bridge (on the right). This was an open shutter exposure combining flash – all fired together – with the train lights turned on for a second or two.

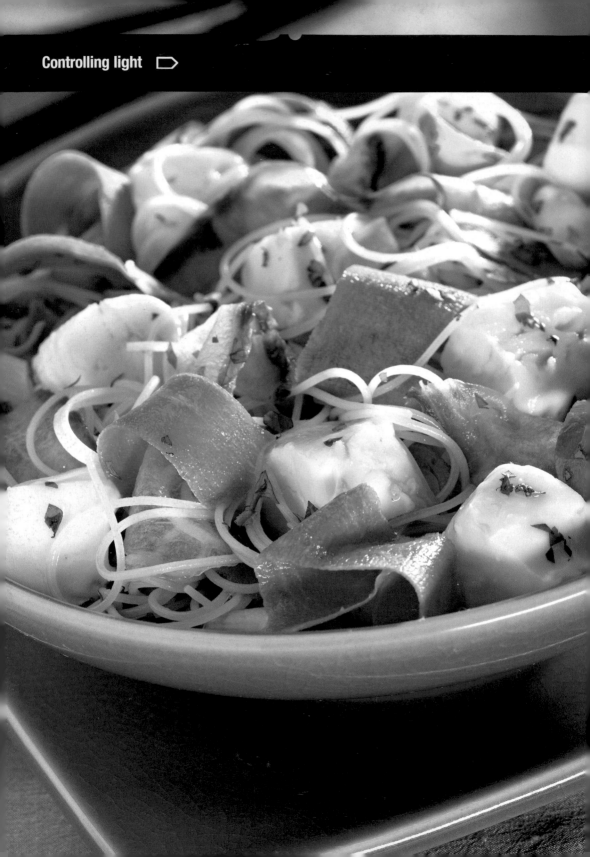

Without light, there is no photography. Light in the natural environment can be controlled by the photographer but only to a small degree. Usually, that means waiting for the sun to move or for the weather to break. In the studio, however, the photographer has complete control over both the source(s) and the quality of light.

To have total control of light, the best studio to work in is a completely black-painted room that has no windows or that can be completely blacked-out. (Portrait photographers may disagree, as by choice they often prefer the natural light in a large, glass northlight studio, though they will be at the mercy of the weather and have only limited control of the light.) In a darkened studio, you can introduce lamps and reflectors with different qualities and position them anywhere within the three-dimensional space to create the lighting effect you want. Because we are so used to seeing the effect of natural light on objects, it is good to consider how those expectations will affect what we arrange in the studio. Low-angle light that looks like dusk or autumn may introduce an undesired effect. High overhead light may correctly show the features of the subject but could look too much like noon light, which might give an inappropriate message to the viewer. This can be especially important in commercial or advertising photography.

Studio lighting is not just a whim or fancy but is used to reveal – sometimes to conceal – line, shape, form, space, texture, light and colour. These are the formal elements of composition. It is best to have some understanding of what you are trying to achieve with lighting before ever putting a light on your subject.

The control we have over light in the studio concerns not only the direction and number of sources it comes from, but the quality of those sources. Quality is a combination of things, such as colour temperature (the blue to redness of the light) and the quality of the shadows it casts; whether it is a diffuse source that casts soft shadows or a point source that casts hard shadows. Colour temperature can be changed with gels or filters and by the selection of the type of lamp. The use of light shapers affects the shadows.

**'Light has to be understood before you can begin to control the end result in your photography.'**
*David Bailey (photographer)*

**Noodle Salad (facing opposite)**
The studio environment gives the photographer full control over light sources. Here the direction and quality of the lighting has been carefully judged to reveal the colours, form and textures of the food and tableware.

**Photographer:** Steve Payne.

**Technical summary:** Sinarback 54M (22Mpx) on 5x4 view camera with Sinar digital lens, exposure detail not supplied, ISO 50. Broncolor pack and heads.

## Studios

The most important piece of equipment in the studio is possibly the notebook. Clear records of a particular lighting setup can be used to recreate that 'look' in another studio environment at another time. Good records also form a basis for learning; they need not be elaborate. A simple thumbnail sketch – usually a plan view – of the subject and lights used is all that is needed. Break your plan down into three areas – subject, background and camera position. It is, however, most important to record the type and power settings of each lamp used, to measure its distance from the subject and record its angle of elevation. You may find it easier to record the height above floor level and where it was pointing. Some photographers record an f-stop reading (standardised for the film/ISO sensitivity used) at various points in the setup, at least for the subject and background.

The heavy camera stand often takes the place of a tripod in the studio, though in studios equipped with flash some photographers prefer using the camera hand-held. Many studios are now equipped with wireless (i.e. radio controlled) flash sync that enables the photographer to work freely with only a small sender unit attached to the camera. Unlike the so-called wireless (i.e. without wires) flashguns that use pulsed flashes from a master flash unit to communicate, these systems are dumb and for flash triggering only. However, they do not need line of sight to trigger the flash.

Studios are usually equipped throughout with either ceiling-mounted (high-glide) or stand-mounted lamps. High glides keep the studio floor clear of clutter. Smaller studios will have light tables and scoop tables for still life and pack shot photography. Bigger studios for fashion and lifestyle photography may have changing rooms and sometimes kitchens or lounges that can double up as photographic sets. It is important when hiring a studio to make certain it is appropriately equipped for the subject you will be photographing. You don't need a studio with an infinity cove (see page 122) to photograph a cake but you do if your subject is a car. Check also what is included in the hire price in terms of lighting and access to computer and other equipment. The type of lighting – 'hot' or 'cold' – also needs to be considered.

Planning studio photography needs military-style precision; time is literally money. The subject to be photographed and the client's proposed use of the images will dictate the size and type of studio, whether film or digital will be used and how the job will be proofed and approved (using Polaroid material, on screen, emailed digital images, digital prints or from film transparencies).

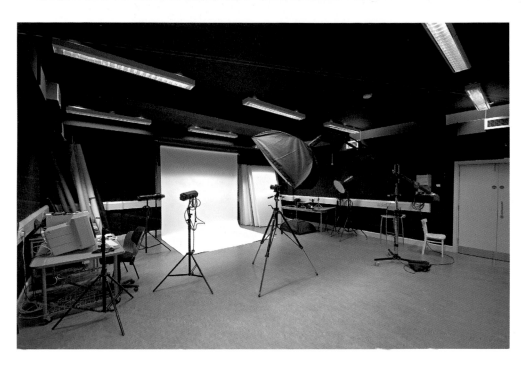

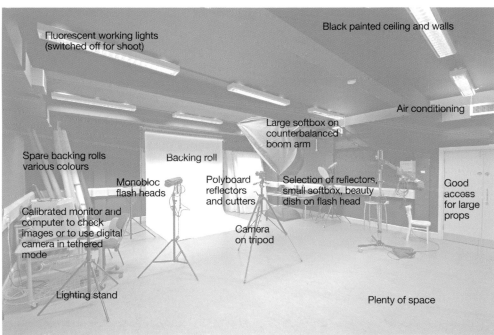

Fluorescent working lights
(switched off for shoot)

Black painted ceiling and walls

Air conditioning

Large softbox on
counterbalanced
boom arm

Spare backing rolls
various colours

Backing roll

Monobloc
flash heads

Polyboard
reflectors
and cutters

Selection of reflectors,
small softbox, beauty
dish on flash head

Good
access
for large
props

Calibrated monitor and
computer to check
images or to use digital
camera in tethered
mode

Camera
on tripod

Lighting stand

Plenty of space

Teaching studio on a college campus – typical of many medium sized commercial studios.

**Working in a studio (health and safety)**
When you walk into a studio for the first time, you should look for the first-aid box and the fire extinguisher before anything else. Photographic studios are not inherently unsafe places but there is a much greater potential for fire or injury than in the average office environment. It may be helpful to conduct a formal risk assessment and it is certainly always worthwhile doing one informally.

Risk assessment is the first part of risk management, which keeps you safe in a studio. You then have to act to prevent accidents from happening. The first step is to identify the hazards – any object or circumstance that has the potential to harm you. Working with water in a studio, for instance, is more hazardous than setting up a dry still life, because lights may fall in the water and cause an electrical short. This is the nature of the risk – what kind of harm can happen and to whom. The risk itself is how likely this hazard is to occur. In light of that information, it is necessary to introduce or implement control measures, which are the steps taken to reduce the risk. Examples of control measures would be: proper training to use the studio equipment; following instructions; getting additional information on how things operate (ask the advice of the studio manager); following 'good practice' and safe systems of working; good housekeeping (keeping the studio clean and tidy) and vigilance (keeping a lookout for new risks and altered circumstances). The risks to someone coming to the studio for the first time – a new model, for instance – would be greater than for the photographer familiar with the studio environment.

**A simple risk assessment table for a small studio equipped with tungsten lamps on stands**

| Hazard | Nature of Risk | Rating | Control |
|---|---|---|---|
| Untidy cables | Tripping | Medium | Training<br>Good housekeeping |
| Hot lamps | Burns to person | Low | Training<br>Safe system of working |
| Very bright lights | Temporary blindness | Low | Training<br>Safe system of working |
| Lamps on stands | Tripping and toppling lamps causing burns, or electrical short or fires | Medium | Training<br>Safe system of working |

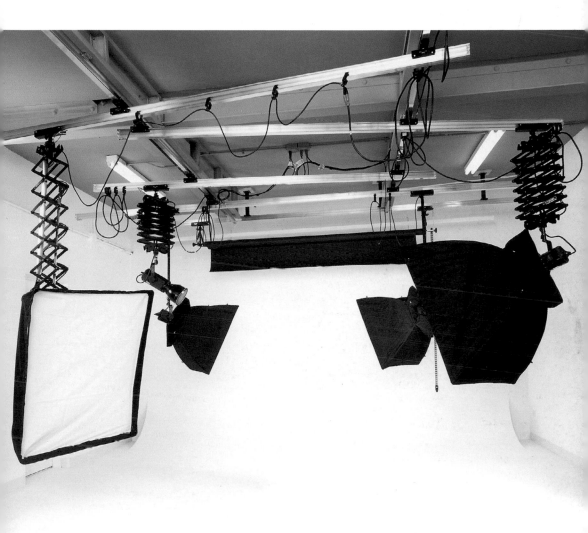

Typical small studio space equipped with high-glide ceiling mounted monoblocs that leave the floor area completely free of clutter.

# Shaping light

### Reflectors

The word **'reflector'** is the term more commonly used for the silvered dishes fitted behind lamps to control and direct the light. The large **flats** are more usually referred to as '**bounces**'.

Almost any large surface can be used to reflect light. Large lightweight items are ideal. Foldaway reflectors are metallised or plasticised neutral-coloured cloth stretched on a spring frame. Expanded polystyrene boards (**polyboards**) tend to get used frequently in studios as they are cheap, lightweight and can be disposed of if damaged. It is best to cover them in white emulsion as, in their raw state, they can absorb a surprising amount of light. Reflecting boxes or elaborate walls can be constructed with polystyrene boards that are easily held together for temporary arrangements with bamboo or metal meat skewers and sticky tape. Reflective 'sentry boxes' for wrap-around reflected light can be quickly custom-built in this way.

Reflected light 'works' in just the same way as a main light source and obeys the inverse square law. If you want to double the effect of a reflector, move it in half as close again as it was originally. If custom reflectors cannot be found then improvisation will be called for. Any large piece of neutral-coloured card, a bed sheet or even a lightly printed broadsheet newspaper, can be draped to catch and reflect light.

Commonly, reflectors are a neutral white or silver, but gold reflectors can be used to warm up the reflected light – 'instant tan' in other words. Manufacturers seem to have reduced the strength of gold reflectors for digital capture and they now have only a hint of warmth in the reflected light. Coloured reflectors can be used judiciously but, if the reflector is out of shot, the viewer may be puzzled as to where the coloured light is coming from. Strongly coloured clothing gives this kind of effect, colouring the shadows under chins, which can be a problem if the image is later cropped.

The wrap-around reflector to outdo all other reflectors is the **tri-flector**. This is a three-panelled reflector with two 'wings' that can be angled to fold the light around the subject. Though Lastolite makes a collapsible version, many photographers have copied the three-panel reflector using polyboards. Even garden photographers have used similar reflectors made of card to wrap, yet control, the reflected light around a single flower head.

Studio bounces tend to be diffuse rather than specular (mirror-like) reflectors. (See pages 150–1 for more information.)

Main light without reflector

With white reflector

With silver reflector

With gold reflector

Softbox above and in front of
the model

Softbox above and in front of
the model with Tri-flector

**bounce** (verb) to reflect light back; (noun) a reflective flat (see flat)
**flat** large sheet of expanded polystyrene or foam core board (lightweight) used to reflect light or cast shadows
**polyboards** expanded polystyrene flats
**reflector** object that reflects much of the light that falls on it, usually white, silvered or gold coloured
**tri-flector** folding reflector with three surfaces; much used in portraiture

## Cutters and flags

Cutters are the opposite of reflectors. The words '**cutter**' and '**flag**' tend to be used interchangeably, though cutters are really larger panels and flags can refer to something no bigger than a postcard. Any material that is opaque enough to cast a shadow can be used as a cutter, as this is the primary purpose of a cutter – to cut light. In other words, to prevent light falling where it is not wanted in the studio. With care about how the reflecting surfaces are angled, any reflector can double-up to prevent light falling where it is not wanted. However, to be true to the definition, a cutter should really be a large black-painted flat.

Still-life photographers worry a great deal about 'image forming light' – this is why they use bellows lens shades to cut out all stray light, thereby preventing lens flare that saps the image of colour saturation. Even with a lens hood, it is good practice to use cutters to control stray light – what photographers call '**spill**'. In anything but a perfectly black studio this 'spilled' light will find a reflective surface somewhere and contribute in an unwanted and uncontrolled way to the image. Looking at the flash synchronisation setup plan on page 93 you will see two large black-painted boards that prevent the light from the flash softbox from falling across the camera lens. The camera 'looks' through a narrow slot in between the two boards and this helps to prevent lens flare. The cutters here are used like a large directable lens shade.

In other setups the effect of a cutter will actually be seen in the image. Part of an image may need darkening down by cutting out the light from the main light source. A cutter, or cutters, would be used to darken a foreground and thus shift the emphasis to the more brightly lit background subject. Once the function of a black-painted board is to prevent reflections, rather than cast a shadow, it would more accurately be called a 'black bounce'. Sometimes, black bounces are used to emphasise the outline of a subject that is photographed against a brightly lit white background. This is achieved by placing them close on either side of the subject, just out of shot. So, whether a black-painted polyboard gets called a cutter or a black bounce depends on its function at the time.

**cutter** matt black painted flat (see flat) used to absorb light

**flag** piece of opaque material often mounted on a boom or arm used to block non-image forming light and reduce lens flare; can be used to control subject illumination

**spill** extra light that 'overshoots' the subject. It can be used on a background or reflected back on to the subject. May produce lens flare and needs to be controlled with barn doors on the lamp or flash head, flags or gobos

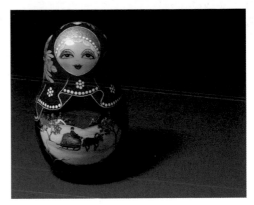

Without cutter and bounces

With cutter and bounces in place

### Seasonal Russian doll (above)

Cutter used to create shadow in background and black bounces used to kill unwanted reflections on the shoulders of the doll and to increase colour saturation. Comparison image was taken in same lighting at same exposure but without cutters or bounces.

**Photographer:** David Präkel.

**Technical summary:** Nikon D100, 60mm Micro-Nikkor AF-D, 1/180 sec at f/27, ISO 200.

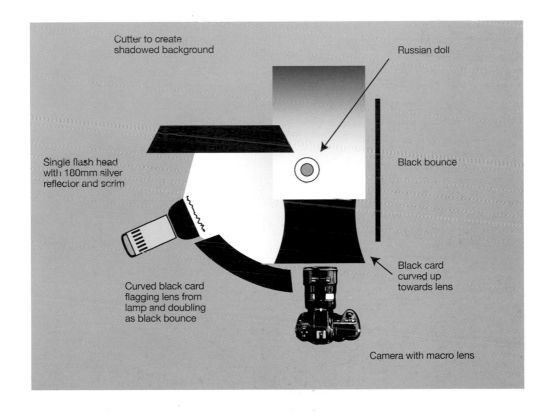

Cutter to create shadowed background

Russian doll

Single flash head with 180mm silver reflector and scrim

Black bounce

Black card curved up towards lens

Curved black card flagging lens from lamp and doubling as black bounce

Camera with macro lens

## Direction of light

The direction from which light falls on the subject has a major impact on the viewer's 'reading' of the image. Imagining the subject – whether a still life or a sitter for a portrait – in the centre of a circle, the light can come from any position around the subject. Some books on studio lighting refer to the direction of light as an angle, while others use a compass bearing or a position on a clock face (with the camera south or at 6 o'clock). You may find it more useful and informative to think of light as being from the general directions: frontal, three-quarter lighting (left or right), side and back. Most are self-explanatory, but **rim lighting** is when the light comes from such a direction as to be largely blocked by the subject, but enough light spills over the edges to illuminate the rim. In **back lighting**, the camera looks directly into the light and the shadow of the subject creates a dark silhouette against a brightly lit ground. Depending on the angle of the camera and light this may produce a halo of light around the subject standing out against a dark background.

These terms describe only the direction from which the light comes, and not the angle at which it falls, which depends on how high the light is and how far away. Lights are sometimes referred to as being high or low. This does not help a lot, as a lamp on a tall stand a long way off will not light the subject at the same angle as one close-to. Better to describe elevation as an angle.

The two extremes are top lighting – when the lamp is above the subject, and base lighting – when it is below. Top lighting with a softbox is common in product photography and can be successfully used in portraiture in a variant of **butterfly lighting**. A reflector or reflectors will be used to throw light back into the front of the subject to create some modelling, though top lighting is rarely used directly overhead. True base lighting requires the subject to be placed on a translucent surface and lit from below. A light table or still life table made of translucent white plastics achieves this.

Elevation of light has already been mentioned on pages 58–9 in the section concerning Daylight. In the studio it can be used to suggest a time of day or time of year: low evening or autumnal sunshine, or high noon.

**back light** light from behind the subject towards the camera, creates rim of light around subject but can be difficult to meter and can produce lens flare
**butterfly lighting/butterfly shadow** lighting from near to and above the camera that casts a butterfly-shaped shadow beneath the nose of the subject on his or her top lip
**rim light** light that comes round the edge of a subject from a source behind or to the side

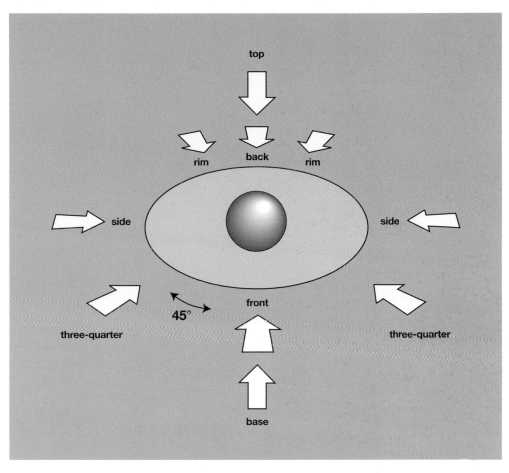

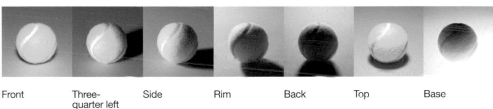

| Front | Three-quarter left | Side | Rim | Back | Top | Base |

## Direction of light (above)

Fixed camera and subject position – only the light is moved – around, above and below the tennis ball.

**Photographer:** David Präkel.

**Technical summary:** Nikon D100, 60mm Micro-Nikkor AF-D, 1/180 sec at f/27, Bowens Esprit monobloc with spotlight attachment.

## Backgrounds

Most studios offer simple black and white paper backgrounds. This is typically supplied in large rolls that are hung from a chain-driven wall or ceiling-mounted system. Some manufacturers produce pre-printed background cloths. These are usually a textured neutral patterning on a 'safe' blue or grey, sometimes with slight metallic accents.

Getting a perfect, evenly lit background requires long strip lights or lights facing away from the background bounced from large polyboard reflectors. When lighting the background directly you need to have the lamps on either side facing across the background to avoid hotspots. It takes a surprising amount of light to produce a bleached-out white background.

The 'infinity cove' is a permanent background, shaped and built into the studio to give a feeling of endless space. It is usually stark white and can be lit with coloured **gels**. The biggest cove can accommodate whole cars, but the look of the background stretching off to infinity can be done small scale with a paper background or the scoop of a still-life table.

'**Gobos**' (go-betweens), or '**cookies**' – as the smaller disks for spotlights are sometimes called – are one way of enlivening a background by casting patterns of light and shade. They come in a wide variety of patterns and pictures, ranging from the generally useful to the downright tasteless. Strips of torn cardboard or crumpled **scrim** hung in front of a lamp may be all that is needed to add interest to a solid-colour background.

More flexible but less easy to control are projection systems. The old 35mm slide projector can give a brightness and intensity of light not easily matched by digital projectors, but the background scene or pattern has to be available as a 35mm mounted transparency.

There is a growing tendency to follow the motion picture use of digital 'green screen' or 'chromakey' techniques. A colour not normally encountered in the real world – a vivid blue or green – is used as a background into which a scene can be digitally composited. It can seem an attractive and quick solution – the difficulty for the stills photographer is to keep coloured reflections off the main subject and to create convincing perspective and lighting effects so foreground and background merge seamlessly.

**Lighting a background evenly**

### In the land of faded times

A virtual photographic background will be the future. Only the model and the small patch of broken 'ground' were shot in the studio. The sky is a separate image. All other elements were added in Photoshop using drawn shapes and real-world textures (paper and cloth). Virtual shadows were created to match the simple studio lighting.

**Photographer:** Jean-Sébastien Monzani.

**Technical summary:** Canon EOS 5D, Canon 35mm f2, 1/160 sec at f/8, ISO 100. Single 350W flash with umbrella.

**cookie** metal perforated disc with pattern or symbol used in a spotlight to project this on to subject or background (see gobo)

**gel** thin coloured transparent polyester sheet used as a filter over a light source to colour it, named after original sheet of thin gelatin

**gobo** (from contracted 'go-between') piece of perforated opaque material (card, metal, foamboard, etc.) used between light source and background to cast pattern in light

**scrim** open-weave fabric used to diffuse light

## Light shapers

There are really only two types of light needed to create a full range of photographic lighting effects – these are the spotlight and the **floodlight**. One gives directional hard light with strong shadows, the other gives diffuse light with soft shadows. Modern lighting equipment – continuous and flash – offers a vast array of ways of altering light. These are known generically as **light shapers**. This term covers everything from a lens or diffuser that is placed in front of a lamp to modify the light coming from it, to the different reflectors used behind the bulb to shape the light beam.

Spotlights permit the projection of patterns on to the background or subject with metal gobos (cookies), or are used more generally as a focusable spot. Some have an **iris** to control the size of the light spot.

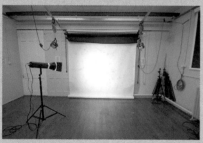

Barn doors can be fitted to a reflector and used to control light spill at the light source, rather like built-in cutters. They give a distinct hard- or soft-edged shadow, depending on the distance of the lamp from the subject.

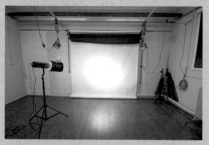

Fresnel spots are flat glass lenses that concentrate the light in a pool.

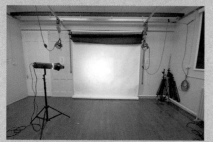

Snoots contain no lens but are used to concentrate the light into a spot – useful as a controllable **hair light**.

**floodlight** lamp used to illuminate a wide area as opposed to spotlight (now more common in theatre and film)
**hair light** lamp or flash positioned to illuminate subject's hair, often used behind subject to light up a rim of hair separating subject from background
**iris** metal blades that create variable aperture in lens
**light shaper** anything that modifies the light from a lamp or head

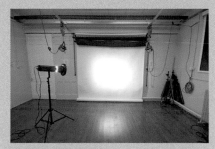

Honeycombs restrict the beam and soften the light to some extent; the bigger the grid the wider the angle of the beam.

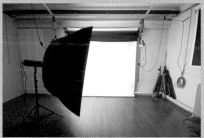

Softboxes are now favoured over the once ubiquitous umbrella. They give a very soft light that imitates bright, but not sunlight, window light. Produce soft shadows that minimise texture.

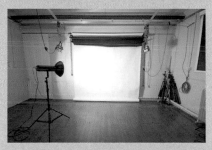

Diffuser dishes are large white reflectors that produce a soft light; the light source is hidden by a diffuser cap (which can be removed to create a large direct reflector).

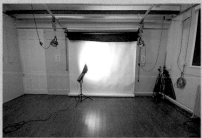

Backlight reflectors produce an oval-shaped pool of light that is usually used on backgrounds.

## Building lighting

The simplest studio lighting for portraits is with just one lamp; this closely imitates the natural look of sunlight. (The ideal single light for portraiture is the so-called **northlight** window – a window lit by a bright sky.) Lighting from the front illuminates the face evenly and gives a 1:1 lighting ratio across the face. Look at the images on pages 104–5 and 134–5 where ring flash (or **axial lighting**) and front lighting have been used. Both sides of the face are evenly lit.

As soon as you begin to move the light away from the front and at an angle to the subject (see the diagram and images on page 120–1) you will begin to model the face with a combination of shadows and highlights – in other words, the face takes on a more three-dimensional appearance. If there is no light reflected back into the shadowed side of the face this creates the very dramatic look of **split** lighting. So-called because it splits the face down the centreline of the nose into a lit side and a dark side (see image opposite).

The ratio of light across the face can be adjusted by throwing light back into the shadows using either a reflector or a second lamp. The principal source of light is the main or **key light**; this secondary source – because it fills the shadows with light – is called the fill light. The main light is the dominant light and casts the most important shadows. Its distance depends on the type of light and the highlights it creates. The height of the light is judged by the length of shadow beneath the nose; too high will unflatteringly light the forehead, too low will look flat and cause the sitter to squint their eyes. Younger and feminine faces respond best to lower contrast lighting of 1:2 or 1:3 (one and a half stops) ratio. Higher ratios suit rugged or more masculine faces.

Lighting ratios

3 stops 1:8 f/4 f/11         2 stops 1:4 f/5.6 f/11         1 stop 1:2 f/8 f/11

**axial light** light from a source as close as possible to the optical axis of the camera lens, usually a ring light, that produces flat, shadow-free lighting
**key light** main light source
**northlight** area light or softbox imitating the look of a north-facing window (lit by indirect daylight and Northern Hemisphere only)

### Water gaze (above)

Dramatic split lighting from a single studio flash head throws half the face into deep shadow. The photographer adds to the mystery of the portrait by shooting through a pane of glass on to which water has been sprayed and picks a high camera angle to get an upward-looking gaze.

**Photographer:** Michael Trevillion, Trevillion Images.

**Technical summary:** Nikon F90X, 50mm, 1/125 at f/8, Ilford FP4, Prolinca 2500 flash head angled to one side. No filters or Photoshop.

## Portraits – one light, three-quarter lighting

Lighting that comes from an angle of 45° relative to the centreline of the head is called three-quarter lighting. It can come from camera left or right (see diagram on page 121). This lights one side of the face well, yet puts enough light on to the shadowed side of the face to model it.

Portraiture is the art of bringing out the character of the individual sitter. Because we are not taking images for the purposes of official identification, sitters do not need to face squarely on to the camera. A portrait photographer would naturally encourage a sitter to turn his or her head towards or away from the camera (after the inevitable conversation about which is the 'best side'). This makes one side of the face appear wider than the other. These are referred to as the broad and short or narrow sides of the face. This is where the two variants of three-quarter lighting get their names: broad lighting and short lighting. With broad lighting, the main light is on the side of the face turned toward the camera; with short lighting, the main light is on the side of the face turned away from the camera. These two types of lighting can be used to alter the look of the width of the sitter's face. A narrow face can be made to look wide with broad lighting (easy to remember).

Centre line

◄──────► ◄►◄──────►

Broad     Narrow
or Short

Square to camera

Short lighting (main light only)

Short lighting (main and fill light)

Broad lighting (main light only)

Broad lighting (main and fill light)

### More than one light

If you flick through any book on lighting you will find elaborate setups using many flash heads or light sources – 11 was the most I found. These arrangements may seem bafflingly complex, but not if you break down the function of each light and realise that photographers sometimes use banks of light that act as one.

The most important light is the main or key light; its qualities (whether it produces hard or soft light) will be chosen to suit the subject and its direction and height chosen to cast the main shadows and provide the desired modelling effect. The fill can come from reflectors or a fill light/or lights. This puts a controlled amount of light into the shadow areas that have been created by the main light to reveal some detail. The fill light reduces the lighting ratio and controls the contrast in the image.

**Effects lights** are those used to pick out particular features or details. In portraits, it is quite common to use a snooted light on a high stand, well behind and well above the sitter on the opposite side from the main light. This puts a highlight into the hair, which helps separate the sitter from the background. The background itself – if it is not to be black – must be lit. This is the function of background lights, which are often used in banks and sometimes additionally reflected off bounces to achieve an even spread of light. A projection spotlight may be used to throw images or patterns on to the background using gobos (cookies).

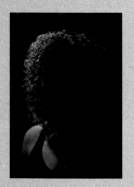 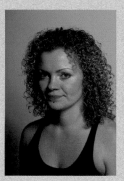 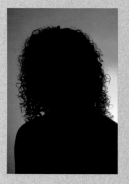 

Effects light (hair light) only   Main light only      Background light only      Fill light only

### Halo lighting

Using a strong light directly behind the sitter's head creates a halo of light through the hair and makes the subject stand out dramatically from the background. This is usually achieved using a snooted light placed behind the sitter so it cannot be seen from the camera position. The width of the beam is adjusted to just cover the back of the head.

**effects light** a small light – neither the key light nor fill light – used to illuminate a small portion of the subject, often a mini spotlight. Sometimes known as FX light

## Bianca (above)

Classic portrait lighting using main light to create modelling, fill light to moderate shadows created by main light, effects light on hair and background light to create coloured background.

**Photographer:** David Präkel.

**Technical summary:** Nikon D100, 60mm Micro-Nikkor AF-D, 1/180 sec at f/16, ISO 200, four Bowens Esprit 1000 flash heads – main light beauty dish, fill light 75x150cm softbox, snoot on effect light and blue gel on background.

## Rembrandt lighting

Rembrandt lighting is sometimes referred to as 'Old Master' lighting. It is the lighting from a single source as seen in some of Rembrandt van Rijn's (Dutch painter and engraver 1606–69) paintings that is its inspiration. There is probably more to be learned from looking at how Rembrandt handled light in his paintings than from any number of books on lighting technique.

Just as the use of butterfly lighting can be identified by the distinctive shadow under the nose, Rembrandt lighting can be distinguished by a small triangle of light under the eye on the broad side of the face. Some photographers actually call the triangular patch of light 'a Rembrandt', which the purists will say should not be wider than the eye socket or longer than the nose. As with all lighting arrangements, what looks good on the day with a particular face should dictate, rather than arbitrary 'rules'.

Unusually, with Rembrandt lighting it is the narrow side of the face that is lit; the side of the face turned away from the camera. The light fills this side of the face and spills over the arch of the nose to catch the cheekbone and cheek on the broad, shadowed side. Lighting the narrow side of the face concentrates the light in a smaller area and dramatically emphasises the outline of the side of the face against the background. The lighting also highlights and models the nose, though care has to be taken over camera height and angle for models with larger than average noses.

Without fill light, Rembrandt lighting is a highly dramatic lighting style, best suited to sitters with a strong bone structure. Fill lighting can modify and soften the drama while retaining the overall quality and direction of the lighting. The fill lighting can, of course, be supplied either by a reflector or by a second diffuse light source, such as a softbox or umbrella. Just as the height of the main light in butterfly lighting is adjusted using the nose shadow, so the height and angle that the main light strikes the sitter is adjusted for Rembrandt lighting by observing the triangle of light on the cheek.

**Rembrandt van Rijn Self portrait c. 1660–63 (oil on canvas) (left)**

The distinctive triangular patch of light is under the artist's left eye.

## La fleur divine (IV) (above)

Modified Rembrandt lighting gives an exquisite painterly effect.

**Photographer:** Eric Kellerman.

**Technical summary:** Large 75x150cm softbox, with **eggcrates** to photo left at angle of 30° below the sitter. Large polystyrene bounce photo right inclined towards sitter, parallel to plane of softbox. Light sunk behind, and hidden by the sitter, illuminates the background paper.

**eggcrates** interlocking cloth grids for use on softboxes, work to pool the light as a honeycomb does on a bare bulb

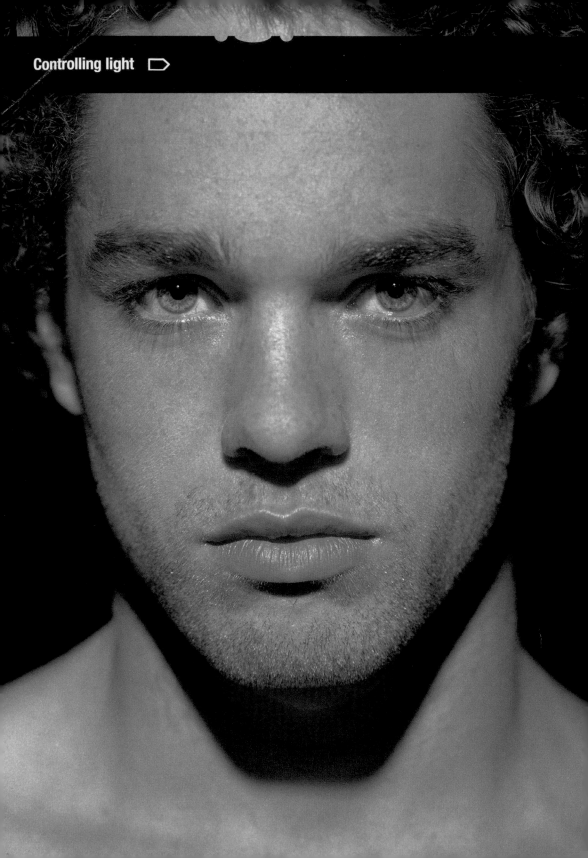

# Butterfly lighting

'Butterfly' lighting is a style of glamour lighting using high frontal main and fill lights, almost in imitation of strong summer sun. The Hollywood sun and glamorous associations of the style are echoed in the other name sometimes used to describe this lighting style – 'Paramount' – after the film studios of that name. This was the kind of lighting used to create the front-of-house publicity pictures for movie stars and starlets.

The name 'butterfly' comes from the distinctive butterfly-shaped shadow that appears beneath the nose and extends someway down the top lip of the model. The appearance and shape of this shadow can be used to position and balance the lights that create this distinctive and appealing look. It is a beauty or glamour style of lighting best suited to women, as it emphasises the structure of the face. Because of the high angle of the lighting, this will lay emphasis on the eyes and cheekbones with highlights.

Butterfly lighting is usually quite symmetrical and it can be difficult sometimes with floor standing lights to place the camera, fill and main lights in the necessary vertical array. Lamps on a high-glide system give the photographer space to work beneath them where stands could get in the way. If the lights are skewed to one side, the 'butterfly' will appear lopsided and the lighting loses its glamorous qualities. If the lights are positioned too high and the shadow lengthens too much down the top lip, again the effect is lost. A simple reflector can be substituted for the fill light. While it is possible to use a reflector below the main light to fill some of the shadows, the shadow under the nose must remain visible for the look to be successful.

It is not usual to light male models in this way as the high lighting can unflatteringly emphasise the forehead, especially if the camera is at or above the model's eye height. It can also unnaturally highlight the ears in both men and women whose hairstyles do not cover their ears, while the butterfly shadow can look absurd on men with beards or moustaches.

**Routledge (facing opposite)**

The butterfly shadow on the top lip beneath the nose gives away the high frontal lighting for this model portfolio shot – here the light has been lowered so as not to give dark shadows in the eyes and the strong single light source has not been softened with fill light as it would be to give a softer, more glamorous effect. A strong under-chin shadow has been filled with a little reflected light but retains a masculine strength.

**Photographer:** Rod Edwards.

**Technical summary:** Mamiya 645 Pro TL, 150mm Mamiya lens, 1/125 sec at f/8 Fuji Reala transparency film, Elinchrom flash head.

## Commercial lighting

The expression 'to put something in its best light' could have been written for the commercial photographer who produces what are known in the trade as '**pack shots**'. This is a recognised form of product photography using simple top or frontal lighting – 'pack' shots being shorthand for packaging.

A well-known studio exercise for students was to photograph a breakfast cereal pack with a large format camera. The outcome was judged not only on how square and how in focus the box was, but also on the quality of the lighting in revealing the appropriate tone on each side of the box and crisp detail of the printing. These are important as they are the very things that need to be right in a pack shot.

The pack shot is usually a form of tabletop photography. The principal light will come from an overhead or forward-tilted softbox with reflectors placed to either side and sometimes wrapping around the front. Depending on the precise nature of the product – whether it is reflective or textured – additional lights, bounces or sometimes small mirrors, will be used to judiciously add highlights. This is the world of clamps, Blu-Tack® and balancing acts. Quite often, a graduated coloured card will be used to enhance the fall-off of light on the background or a shadow cast from an overhead piece of card used to create a soft edge (see pages 118–19 on Cutters for this effect).

Pack shots often involve a 'production line' approach in the studio. A standard lighting arrangement will be left set up and fine tuned for each product – in fact, there are specialist pack shot studios that produce nothing else, so much are these simple, clear images in demand for the print media or web use.

Pack shot studio showing typical arrangement with overhead softbox on **boom**, graduated colour card background, small strip lights on the tabletop and reflectors. The monorail camera has a digital back controlled by the computer on the table to the left.

**boom** long counterbalanced arm to support lamp or flash head over subject in the studio
**pack shot** a product image for commercial or advertising purposes – from 'packaging'

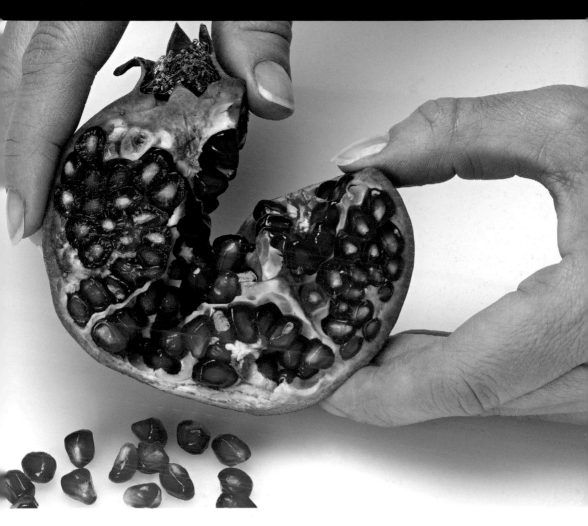

### Pomegranate (above)

The crisp, clean lighting of a classic pack shot.

**Photographer:** Steve Payne.

**Technical summary:** Sinarback 54M (22Mpx) on 5x4 view camera with Sinar digital lens, exposure detail not supplied, ISO 50. Broncolor pack and flashhead with large softbox.

## Light tents

The light tent is an essential accessory for any photographer working with subjects that have reflective surfaces. The 'nightmare' product to light is a highly polished motorcycle crash helmet or stainless steel kettle. A reflecting sphere like this will not only show bright highlights from almost any light source however diffuse, but will also show the photographer at work reflected in miniature, as well as the studio surroundings that are normally well out of shot. A light tent – that is the generic name for both the loose fabric and rigid plastics versions – is the only solution.

By draping or surrounding the reflecting object completely in white diffusing material (white cloth or white translucent plastics), the reflections in the mirror-like surfaces are now of a diffuse white light source. The camera lens can be pushed through a slit in the cloth or an aperture in the solid plastics tent and the tent itself lit from outside. Digital image editing means that this small reflection can be easily cloned or patched out. The general principles of lighting and modelling apply, though secondary light sources have to be used instead of passive reflectors. The further the light is away from the tent, the more diffuse the light and the lower the contrast. (Be careful with hot lamps near tents and plastics cocoons.) It is always worthwhile taking a custom white balance or, for film users, judging the colour of the light inside the tent with a colour meter, to adjust for any colour shift the tent material has had on the colour balance of the lights in use.

The rigid cocoon has one major advantage over the cloth light tent as it can be suspended and lit from beneath. It is quite capable of carrying some weight, but placing it on a glass table over the lighting gives greatest control.

Small highly reflective objects, like jewellery, can be photographed with an improvised light tent made from a cone of white paper cut on an angle to give access for the camera lens.

Lighting setup for a light tent.

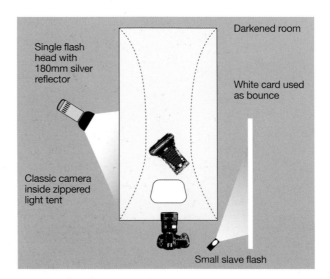

Darkened room

Single flash head with 180mm silver reflector

White card used as bounce

Classic camera inside zippered light tent

Small slave flash

**Polaroid 110 Pathfinder classic 'instant' picture-roll camera (below)**

'Museum' quality image produced for book publication. Black and chrome subjects need careful treatment to capture the wide subject contrast – low lighting ratio used to keep the subject brightness range within 7-stops. A pine wood surface was allowed to show underneath the milky white polyethylene base of the light cocoon to give a slight golden glow. Light fall-off towards the back – cove section – of the cocoon was encouraged to give a gently graded background. Main lighting was from the side, diffused sufficiently by the cocoon not to cast deep shadows towards the camera. The lens and lens panel of the camera were carefully lit with soft, reflected light from a battery-powered slave flash.

**Photographer:** David Präkel.

**Technical summary:** Nikon D100, 60mm Micro-Nikkor AF-D, ISO 200, 1/60sec at f/32. Red Wing/BKA Cocoon 130 Light Tent with Multiblitz compact 200w/s flash and Wotan SC18 Servo flash.

### The Janitor (above)

This scene was created entirely in a studio chosen for its flooring. The janitor is a model.
The hyper-real lighting creates the mood of this being a still photograph taken on a movie set.
The viewer engages more with the image and begins to look for narrative and backstory.

**Photographer:** Scott Ritenour.

**Technical summary:** Sinar view camera with Phase One P25 digital back (22MPx), Nikkor SW 120mm f/8, ISO 100 exposure details not supplied. 12 flash heads, spotlights and honeycombs with straw and half-straw gels. Photoshop to clean-up wall and modify photograph on wall.

## Cinematic lighting

Cinematic lighting is not lighting *for* the movies but lighting for still photography that *looks like* the movies. The movie industry employs skilled lighting cameramen (men and women) who can create the exact lighting ambience with the controlled use of natural and artificial light sources. Like many film directors, both Stanley Kubrick and Wim Wenders enjoyed roles as photographer and cinematographer. Wenders even produced a book of specially photographed images he called a 'film book' based on his film *The Million Dollar Hotel* (2000).

Sometimes what we 'read' as heightened reality in the lighting of a motion picture scene is quite unreal, with 'natural' light coming from more than one direction at once. Still photographs lit this way become cinematic tableaux that are edgy and full of narrative tensions. The more these images look like stills from a movie, the more we want to know the plot line and the backstory of the character.

Photographer Philip-Lorca diCorcia controversially exploited this language in a series of still images called *Heads*. diCorsia set up sophisticated flash lighting in Times Square, New York hidden from passers-by. This created a small 'pocket' of the hyper real within the real world – like a little bit of Hollywood landed in reality. Camera and flashes were remotely triggered as suitable subjects approached – one sued, though his case was dismissed. The resulting images are remarkable – candid portraits of people around whom imaginary stories coalesce.

No less an authority than Leonardo da Vinci wrote in his notes: 'Objects seen in light and shade, show in greater relief than those which are wholly in light or in shadow.' This is what photographers mean when they talk about light 'modelling' the subject. By casting shadows we create tonal variations that, applied to shape, give the appearance of the third dimension in our two-dimensional medium.

Every material and object we go to photograph has specific physical properties than can be revealed, enhanced or hidden by how we light it. These properties are usually part of our emotional reaction to an object. To communicate and amplify this response, the photographer has first to be aware of the qualities of the subject being photographed and then light them with appropriate care to reveal the important aspects. A thistle would look quite unthreatening and almost downy in diffuse, high-key lighting, whereas a hard light would cast dramatic shadows from every spike.

Not only are we concerned with the formal elements of composition here (line, shape, form, space, texture, light and colour) but especially with additional properties that come from interaction with light itself – transparency, translucency and opacity – and reflected light, which gives us tone and colour. These properties are the result of shining a light through – or at least trying to in the case of an opaque object – rather than on to an object you are photographing. They can add the quality of depth to what is otherwise just surface.

The final section of the book is concerned with photographing light itself and alternative ways of using light to create images. It is not only cameras that create images. The shadows that objects cast themselves can be directly caught on photosensitive paper without the intervention of a lens or camera. The humble flatbed scanner can be a powerful creative alternative to the camera for some types of image, rivalling and even surpassing its resolution. Photography often seems only concerned with the instant, but images can be produced that record light moving through time. Light can even be used to paint an object in the dark.

**'Wherever there is light, one can photograph.'**
*Alfred Stieglitz (American pioneering art photographer)*

**Honey (facing opposite)**
Very simple lighting is used with great precision to emphasise the translucent qualities of the honey and the mirror-like surface and shape of the spoon. There were many hours of pouring to get the shot perfected.

**Photographer:** Packshot Factory Limited.

**Technical summary:** Hasselblad H1, Hasselblad 120mm f/4 HC AF Imacon Ixpress digital back, ISO 100, exposure details not supplied. Lit from behind through a perspex sheet with white card reflectors at the front.

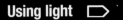
## Quality of light

### Transparency

A transparent object allows light to pass through with little interference. In other words, you can 'see through' to the other side of a transparent object, which itself may be clear or coloured. Glass and water are the perfect examples. Photographs tend not to be of the transparent object itself but of the effect it has on objects seen through it; the slight folds and imperfections that create interesting distortions of reality. Coloured glass is a delight to photograph as it can be used both to cast coloured light into the subject – as with stained-glass windows – or to colour and warp the world when seen through the glass.

One of the classic still-life subjects is the wine glass or bottle. The typical approach is to use a high camera angle and a low light angle to photograph the shadows cast by glass on the surface on which it sits. The same idea pertains to the rain-covered window that will cast ripples and shadows on the face of anyone looking through it. This technique heightens the modelling of the sitter's face as the completely planar pattern from the transparent glass and rain is mapped on to the surface of the face, contrasting the flat with the three-dimensional and giving strong form.

Water has peculiar properties when photographed as it has both specular surface reflections and transparency that in clear water lets us see into its depths. The surface reflections may be part of the composition and will come into focus at a different point from that which is seen through the water (this is especially true in shallow water). The surface reflections can be controlled independently of the image seen in the depth of the water by the use of a polarizing filter. Moving water photographed with a time exposure appears translucent rather than transparent, but flash will freeze the movement of the most animated water splash. Glass and water may also act as lenses to magnify a view or as prisms to create a spectrum.

Ice is a particularly popular subject for still-life photographers who will freeze a variety of flowers, fruits and vegetables in its depths, photographing the distortions and slight diffusion the ice and trapped bubbles bring.

### Palais des Congrès de Montréal, Canada (facing opposite)

The architectural focus of the building is on light and transparency. The coloured panes both colour the view of the outside world and cast pools of colour into the interior. While an overcast day is best for traditional stained-glass windows, here the sun casts crisp shadows and emphasises the building's form in bordered slabs of colour.

**Photographer:** Alain Gauvin.

**Technical summary:** Holga camera fixed plastic lens aperture around f8 and fixed 1/100 sec shutter speed, Fuji Provia 100 in sunlight.

## Translucency

Translucency means 'to pass light'. Unlike a transparent object that passes both the light energy and a coherent image, a translucent object will pass the light energy but will break up or diffuse the image. Opal glass or a milky liquid would be good examples.

Transparent water takes on a foaming, milky appearance when photographed with an exposure longer than about 1/4 sec. The flow is apparent but the individual reflections and bubbles merge into a blur. Smoke and steam have similar qualities when treated to long exposures and, more than water, can appear to be internally lit.

When light is shone at a translucent object – a polished semi-precious stone, for instance – the surface reflections tend to distract from the light that passes through and diffuses within the object. To emphasise this quality in the studio it is best to direct light into the object and light the surface separately, if at all. The traditional ruse is to use a light box or light table with concealed lighting from underneath the object. The item is placed over a hole cut in a piece of dark card to match its outline and lit from beneath. Producing the classic image of the 'glowing' single egg in the tray of otherwise normal eggs is almost a rite of passage for photographers. Optic fibres and tiny, high-intensity white LEDs can be used inside small objects so they seem lit from within; an especially successful technique with seashells.

The combining of images, one for the surface reflections and one for the translucent depth, was always possible with film but has been made much easier through the use of image editing software. Two separate exposures with diffuse lighting for the reflection and strong transmitted light for the translucency can be blended in any combination using layer opacity.

### The elephant (facing opposite)

The curled dead leaf of a Hosta appears to glow with light; caught between a softbox giving back lighting and a carefully balanced reflected light that gives some surface detail without losing the translucency.

**Photographer:** Marion Luijten.

**Technical summary:** Canon 5D, Sigma 105mm macro, 1/125 sec at f/18, ISO 100.

## Opacity

An opaque object is one that lets through no light. Before portrait photography there was the silhouette. Extremely skilled artists would draw – or cut from black card – the outline of a person's profile view. To create a silhouette in the studio requires lighting from behind that will cast a deep shadow forwards. There must be no frontal light falling on the subject; either that or the exposure must be short enough – and the background lighting therefore bright enough – for no shadow detail to be recorded. This form of lighting abstracts and emphasises the shape of objects and reverses the effect of modelling light by taking solid objects and making them appear as simple flat shapes.

A back-lit subject with no visible detail has a mystery about it and may take on iconic status if the shape is sufficiently recognisable.

The simple alternative to photographing the unlit object against a bright background is to photograph the shadow of the object projected on to a plain surface. There are many images that deal solely with the shadows cast by objects as a photographic means of simplifying the subject. Often, the subject that has cast the shadow is intentionally hard cropped to give only a hint of the source of the shadow, or it is missing completely from the final image. Shadows are a means of distorting the shape of a recognisable object as they will drape themselves over the contours of the surface on which they fall, turning through a right angle, for instance, as they run across the floor and up a wall. With the appropriate angle of light they can be mysteriously elongated and used to create a mood.

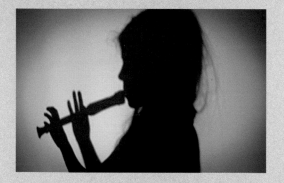

**Recorder player (left)**
A crisp shadow from a point source retains both character and moment.

**Photographer:** Jeremy Webb.

**Technical summary:** Nikon D50, 18–55mm AF-S at 32mm, 1/50 sec at f/4.5, ISO 800, 500 watt tungsten E21 Photoflood bulb.

**Cast a long shadow (facing opposite)**
Silhouette and shadow created simply with a flash head lying on the pavement pointing towards the camera.

**Photographer:** Michael Trevillion, Trevillion Images.

**Technical summary:** Nikon F90X, 50mm, 1/30 sec at f/5.6 (to use some ambient light), Ilford FP4, Prolinca 2500 flash head at dusk. No filters or Photoshop.

## Reflection

A reflection is light bouncing back off a surface. There is a law of reflection that states that the angle of the reflection is always the same as the angle at which the light falls on the surface – the angle of incidence. (These are the terms used to describe the two types of light meter.)

The photographer has to deal with two types of reflection. Reflections which retain the image are described as specular, which simply means 'mirror-like' after the old word for mirror. Specular reflectors bounce back most of the light energy that falls on them. There are also diffuse reflectors where some proportion, but not all, of the light energy is bounced back but the image is lost. You can imagine a range of reflectors along the spectrum from specular to diffuse, from a silvered mirror to rough felt cloth.

Photographing objects with diffuse reflections is much more easy than specular reflection as there is no need to worry that the studio, photographer or lighting setup is reflected as an obvious image in the shiny surface. Any object with a shiny metallic or dark gloss finished surface has these properties. For this reason, they will most commonly be photographed in a light tent where there are only diffuse light sources to reflect.

Glassware poses its own problems as it is both transparent (or translucent) and highly reflective at the same time. Lighting setups that suit one aspect may not suit the other. Black bounces are regularly used to give clear glassware a structural line or substance, while long strip lights or strongly lit bounces are used to give long reflections in bottles.

A 'window frame' made from strips of gaffer tape on a softbox can be strikingly effective when seen in reflection. We are all familiar with the regular grid of window frames and get a stronger impression of the form and contours of the object on which the refection is falling as it distorts this regular pattern. A catchlight in a sitter's eyes that appears to be a window frame immediately makes the portrait less obviously studio-bound.

Note: Polarizing filters work only in sunlight, they do not work to control reflections with studio lights unless polarizing gels are fitted.

**Beer (above)**

Reflections in glass, metals and liquids cannot be left to chance in the studio. A soft box to the right of the glass, with a diffuser to further soften the light, gives one reflection while a second, on the left, is from a white card reflector. A spotlight with a honeycomb shines down into the glass to give life to the beer. The graduated background is a perspex screen lit from below and towards the camera, the glass mounted on a perspex box to catch light from beneath. The shot was repeated until the bubbles and the pour were right.

**Photographer:** Packshot Factory Limited.

**Technical summary:** Hasselblad H1, Hasselblad 120mm f/4 HC AF Imacon Ixpress digital back, ISO 100, exposure details not supplied.

### Lauren (girl in red) (left)

Diffuse light – there is wonderfully soft light to be found in the shade; contrast has been further reduced by the use of a reflector.

**Photographer:** Rod Edwards.

**Technical summary:** Nikon F90X, Fuji Reala ISO 100 exposed at EI 64, 1/500 sec at f/4 in open shade. Lastolite foldable reflector beneath the chin to soften shadows. Contrast enhanced in Photoshop.

### Misty morning, Skitaca, Croatia (below)

Atmospheric diffusion – fog and mist reduce the tonal palette and simplify the image by obscuring detail.

**Photographer:** Branislav Fabijanic.

**Technical summary:** Olympus E-300, Zuiko Digital 14–45mm, 1/200 sec at f/8, ISO 200, levels adjustment and toning in Photoshop.

## Diffusion

Diffuse light is light that is scattered and 'incoherent'. Diffuse light in the studio can be rather different in its effect from diffuse light in nature. Photographic light can be diffused and scattered to give a soft lighting effect in the studio by the use of nets or scrims over the lights. The thicker and more 'diffusing' the scrim, the more power will be needed to maintain a given exposure. Large sun-scattering panels of stretched scrim can be used overhead and out of shot for fashion and portraits to soften harsh outdoor light. Some form of diffusion is almost essential for beach photography. Certain of these panels are now manufactured with a double thickness of scrim-trapping loose material between, which can be ruched up and arranged to give an attractive dappled light.

The softer the subject's skin the better it responds to something other than flat, directional studio lighting. Children look far better in the dappled light around the edge of a tree than out in the bright sunshine; it also means that their eyes will not be screwed up against the light. In the studio, **diffusers** can be used to imitate the attractive effect of the light percolating down through a leaf canopy.

The other form of diffusion is atmospheric, rarely encountered in the studio unless a smoke or fog machine is used. On location, low cloud, mist and rain will all diffuse the light. They bring their own form of simplification in the lack of detail and resolution in the resulting image and the desaturation and simplification of the colour palette. Any distant view will be seen through 'layers' of mist and this will increase the sensation of depth in the image – this is called aerial perspective. Many photographers pack their gear away in poor weather conditions but it can be uniquely rewarding to persevere and explore the special quality of diffuse light.

Fog and diffusion filters can give something of the effect when you cannot wait for the weather to change. Sometimes a more effective solution is to fit a cheap UV filter on the lens and simply breathe on it; they give quite a different effect from true soft focus lenses.

**diffuser** piece of cloth, netting or translucent material used over light source to spread light over a wider area and soften shadows

## Revealing shape

### Back and rim lighting

While complete back lighting will create silhouettes casting the shadow towards the camera, this can be modified by gentle front reflected light that will give a hint of detail to what would otherwise be shape alone. There are other circumstances where the drama of simple shapes is quite enough. This form of simplification is a photographic device that has been used over and over again.

Rim lighting is a dramatic version of back lighting. It can be so well defined as to look like someone has gone over the edges of the image with a highlighter pen, or it can gradually show a more blended effect with a less emphatic line. In its purest form, the back light is symmetrically arranged and the beam just covers the subject area without spilling forward. The rim of light that is produced will naturally stand out from the background to some extent, but it is ideal if the background is intentionally made dark. Soft hair and rough textures work best with this lighting, smooth objects show more of a distinct line and complex smooth shapes may need more than one rim light to create the appearance all round.

Moving away from strong symmetrical rim lighting, the light source that is obscured by the subject can be moved round. Its energy then spills over the edges, still lighting them with intensity but, because of its angle, producing an area of tone before the light rapidly falls away to the deep shadows created by the light still being largely behind the subject. In the studio, it is probably easier to move the light. In the real world the photographer will have to move around to get the correct relationship between the light and the subject.

Getting a correct exposure for rim lighting can be difficult. Using an incident light meter near the lit rim, point the meter at the light and take a reading. This will give an exposure that will show the lit edge as middle grey. To increase the brightness of the outline effect, increase the exposure by up to 2 stops. Check the background reading is 4–5 stops away to keep it looking dark.

### Who are these guys? (above)
In the old cattle market in Aalborg, Denmark, strong back lighting throws shadows forwards and conceals the faces. A narrative is suddenly created.

**Photographer:** Bjørn Rannestad.

**Technical summary:** Canon EOS 350D Canon zoom at 21mm, 1/80 sec at f/9 ISO 100. Exposed for highlights but raw file give +2EV compensation to open up shadow detail in Canon Digital Photo Professional. Converted to black-and-white from digital colour original.

**Anne (above)**

Shallow-angled lighting from behind and camera right gives dramatic modelling to the body forms.

**Photographer:** Denis Olivier.

**Technical summary:** Konica Autoreflex T3, Hexanon AR 50mm f/1.4, exposure not recorded, Kodak TMax 400 developed in Rodinal, simple halogen light source.

# Revealing form

## Modelling light

The lighting described as three-quarter lighting in the section on portraits (see pages 128–9) is the ideal light to reveal the three-dimensional qualities of almost any object. This is when the best shadows are cast for us to understand the volumes and form of the object. Ideally, the three-quarter lighting should be from a source at about 45° elevation – that's when the lighting looks most like the sunlight of our everyday world which, not surprisingly, is how we can best make unambiguous judgements about the shapes of three-dimensional objects.

Once we have form in an image, viewers will begin to react with some emotion. The fullness of an earthenware jug or bowl, even the gleaming curves of a car, spark an emotional reaction in the viewer as they trigger a memory of the touch sensations associated with the object. Careful control of lighting to strengthen or exaggerate the solidity will only enhance the emotional response. Good still-life, nude and landscape photographers have an instinctive understanding of this and will always look for the best modelling light for their subject.

Breaking up the incident light into a regular pattern and letting the stripes or repeating shapes fall across the surface of the object is another classic photographic device. Picket fence shadows and the light that falls from big windows with many, small windowpanes dramatically reveal the surface contours and form of an object in the contoured distortion of their repeating shapes.

A shape is 'converted' to a solid by highlight and shading. A cast shadow anchors the solid object on a plane and further enhances the illusion of the third dimension in the two dimensions of the page.

# Revealing texture

### Side light

Side, oblique and raking light are three descriptions of the same thing. Imagine a ploughed field at sunset with the sun going down behind the furrows. The light will shine brightly on the top of each ploughed mound but will cast a long, deep shadow into the furrows. This alternate pattern of light and dark emphasises the 'texture' of the ploughed field that would be lost in the flat overhead light of the noon sun.

Lighting from the side of any textured surface will create this micro contrast. A piece of heavily grained wood acts just like the ploughed field when lit from an appropriate angle. While the landscape photographer has to wait for the sun to move round, the studio photographer has complete control over the appearance of texture. First, there is the choice of light source. A hard, directional light will show more effect than a soft light. Second, the angle at which the light 'strikes' the surface of the subject can be modified. There will be very little texture when the light falls directly flat on to the subject but as soon as the light is allowed to skim over the surface it will reveal the texture.

If there is a flow or grain to the texture, the light must be used across the grain to emphasise texture or down the grain to minimise texture. Something with a random texture, like coarse sandpaper, responds only to the angle of light not the orientation. Top and **base lighting** can be just as revealing as side lighting – it is not the direction of the light source that matters but the oblique angle at which the light falls on the subject.

The problem that more often faces a photographer is not how to reveal texture but how to conceal it. Glamour and fashion photographers will light a face with diffuse light from multiple angles to minimise the appearance of skin texture, and even then may resort to Photoshop to remove the last traces.

### Tallulah–Running Water Dress (facing opposite)

Side lighting from the sun reveals the fabulously rich textures as the water erodes and algae grows on the hand-sewn fabrics on Vien Le Wood's Tallulah–Running Water Dress exhibited outdoors at the Fashion at Belsay Show 2004.

**Photographer:** David Präkel.

**Technical summary:** Nikon D100, 18–35mm AF-Nikkor Zoom at 35mm, 1/400 sec at f/11, ISO 200. Sunlight.

**base lighting** light from underneath

# Revealing tone and colour

The advice given to photographers in the early years of colour film was to 'have the light on your back'. The flat, bright light that results ensured the cleanest and most saturated colours with the limited dynamic range of these older slow films. Flat lighting reduces the contrast by minimising both highlights and shadows.

You may presume a bright day with full sun would guarantee the strongest colours, and bright overhead sun can give this if the subject brightness range is not too great for the medium. However, possibly the best days for close-up colour photography are those which are hazy and bright. Bright but diffuse skylight reduces the strong micro contrasts. Flower photographers will often work in reflected light, diffuse light or wait for an overcast but bright day for their flower close-ups to get the strongest, most vibrant colour. Vibrancy means having an underpinning of saturated colour in the darker tones that in strong light would otherwise be just black.

Correct exposure is important, but what is technically correct may not be aesthetically pleasing. An intentional half stop underexposure will give richer colour with transparencies. Many digital SLR cameras already give slight underexposure to avoid highlight clipping and it is always best to check the histogram for the appropriate exposure. Bracketing is always an option; for digital, RAW capture is essential.

Tone is simply the range of greys from black to white and is the concern of those working with monochrome film. Some understanding of Ansel Adams' Zone System helps, as intentional exposure shifts and compensation in developing can be used to capture a wide tonal range on film that can then be reproduced with a full range in the darkroom. Adams taught pre-visualisation, which requires the photographer to be able to imagine the tones in the finished print, and then to manipulate the tonal range seen in the subject so the full range can be reproduced.

His idea is based on eleven tones centred on the middle grey that the light meter is set to measure. Adams puts this at Zone 5, with Zone 0 being total black in the print and Zone 10 being the white of the printing paper – the real image being conveyed in Zones 2 to 8. Adams' idea was that, with exposure adjustment, the photographer could place any luminance value on any zone. This specialist topic is outside the scope of this book but those interested are well served with plenty of published resources in both book form – including Adams' own books – and on the web.

## Sea paint (facing opposite)

Part of the sea wall at Seahouses, Northumberland, where the fishing boat owners have worked out their paint brushes. Strong bright light from a hazy day gives good shadows in the cracks and holes but does not cause glare on the surface, which leaves the colours of the paint well saturated.

**Photographer:** David Präkel.

**Technical summary:** Nikon D100, 60mm Micro-Nikkor AF-D 1/250 sec at f/8, ISO 200, hazy sunshine.

## Experimenting with light

### Photographing light itself

It is one of the first pieces of advice that any photographer receives: 'Don't point the camera at the light'. It is also one of the least useful. Photographing light itself means intentionally pointing the camera at the source of radiant energy rather than trying to capture the light that has been reflected from surfaces.

Light sources with low colour temperatures are most easily photographed: candles, oil lamps, fire itself or the interior of an oven or furnace. You can choose how far to correct the white balance or filter the light to achieve an aesthetically pleasing effect, which is more important in this instance than a technically correct one.

The difficulty comes in metering the subject when the light is unsteady and flickers – bracketing and auto exposure with compensation should get a useable result. High in the sky, the sun offers little interest to photographers (though plenty to astrophysicists who photograph the sun's surface). The setting sun becomes a rich orange disk as it dips towards the horizon but to make it a reasonable size in an image, a telephoto lens of 600mm or longer is required. The light from the sky at sunset can be just as satisfying a subject for those without a lens of this focal length, ranging as it does from deep violet blues to orange and peach coloured tones.

Light reflected and broken up by a wet road surface is a great abstract night subject. It is especially attractive when the view reflects richly coloured neon lights. Intentional defocusing can abstract the image even more, creating overlapping pools of richly coloured light.

Sparks and fireworks are sources of light best dealt with as a time exposure to capture the coloured light trail they leave behind. This is covered in the next section.

Note: You should never look at the sun through the camera when it is too bright to look at with the naked eye, or you may permanently damage your eyesight.

### Glass blower's furnace (facing opposite)

The black sides of the furnace frame a rich spectrum of colour from yellow through to red, emphasising the source of heat and light in the depth of the image.

**Photographer:** Doug Mauck.

**Technical summary:** Sony Cybershot DSC770, built-in lens at 41mm, 1/500 sec at f/4, ISO 100. No Photoshop adjustment or enhancement.

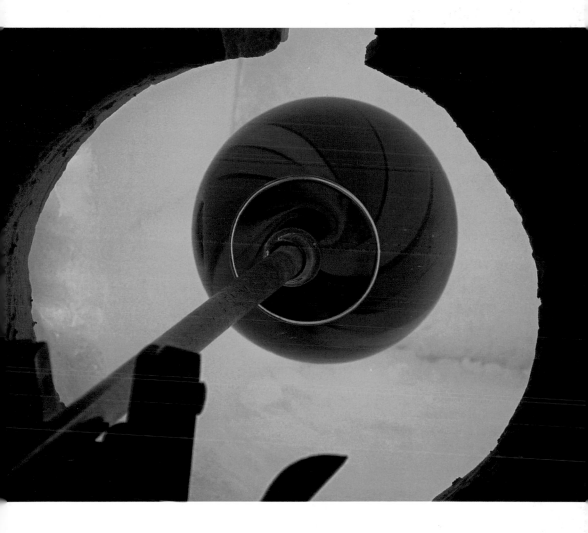

## Moving lights – time exposure

Creating any photographic image involves the law of reciprocity. This is the play-off between the intensity of light and its duration. A bright light for a short period of time will give the same photographic exposure as a dim light for a long period. So, given low light conditions – or that we can create them by reducing the intensity of the light – we can photograph the movement of lit objects or light itself during a long time exposure.

The classic image of a city at night shows moving trails of car tail lights snaking along the roads. This was originally an inevitable side effect of the long exposures necessary to get any image in the low light conditions but has since become iconic.

To create this look, it is usually enough to stop the lens down to its minimum aperture, though for still longer exposures a neutral density filter will be required (see pages 44–5 on ND filters). There are two side effects to watch out for, one with film and one with digital. With long exposures, film suffers 'reciprocity failure'. This is when the linear relationship between time and intensity breaks down and a colour shift may occur that needs correction. Exposure compensation will also be needed. The film data sheet will explain when colour correction or exposure compensation is needed. With digital, the problem is one of noise. Very long exposures in low light conditions will show the inherent thermal noise from the camera sensor itself. Some cameras have a long-exposure noise reduction program that records a second 'image' the moment the shutter is closed. This contains nothing but the noise from the sensor. This second image is subtracted from the first – the real image – in an effort to reduce visible noise. There is nothing inherently 'wrong' with noise and it may even have an appropriate aesthetically pleasing contribution to make in some images.

In the UK it is a 'flashgun', in the USA a 'strobe'. The American name recalls one special use of the electronic flashgun to produce repeated bursts of light during one exposure – the stroboscopic effect. An alternative to blurred light trails, the strobe effect will show movement as a time sequence of superimposed images.

### Pablo Picasso (facing opposite)

Only an artistic genius like Picasso could paint his 'trademark' Minotaur in the air with merely the aid of a pen torch. Main light from the left was a flashgun fired during the time of exposure.

**Photographer:** Gijon Mili.

**Technical summary:** none supplied.

### Moving light – the flatbed scanner

The flatbed scanner is designed to produce digital files from flat reflective artwork or from film transparencies or negatives. However, it is quite possible to scan small three-dimensional objects on a flatbed by placing them on the glass and scanning them as if they were flat art. The images from a flatbed used as a 'camera' have intriguing qualities.

As the light moves with the point at which the image is sampled – the single strip of photo sensors that travels down the flatbed in the scanning head – the lighting has an unusual quality such that anything close to the glass is brighter than anything further away, but there are no real highlights or reflections. It is a very attractive, clear but soft light. Leaving the lid of the scanner open produces an inky black background even in daylight with a rapid fall-off in light from the scanner itself. The depth-of-field is very limited and perspective distorted, so items just a few centimetres above the flatbed will be dark and out of focus. Curving a piece of patterned paper or fabric over the flatbed can easily give an attractive graduated background.

Scanner-originated art is nowadays often referred to as 'direct digital capture' and those working within the field as 'scanner artists'. Carol Selter was an early worker; her 'Ducklings' (1995) is a large colour print of ducklings waddling across the glass flatbed of a scanner captured as pixelated slices of time. Selter's work explored the fact that a scanned image takes time to create and that the first part of the scan is laid down some seconds before the last. You can see this at work by scanning your hand. As the scanner reaches half-way down your fingers, move your hand in time with the scanning head for part of the scan. The result will be elongated fingers.

More recently, Marsha Tudor has used massive, detailed scans of flowers painstakingly rearranged into giant kaleidoscopic digital canvases (exhibition Scanners as Camera 2006). Artists have built tanks to hold liquid on the scanner flatbed and attempted to use old redundant scanners as primitive cameras. This really is an open field for the technically and artistically inventive.

### Three windfalls (above)

The unique soft light, the gentle falling away of focus and of light mark this out as a piece of scanner art, not a large format transparency which it could so easily be mistaken for given its sharpness and detail.

**Photographer:** David Präkel.

**Technical summary:** Profiled Epson Perfection 3490 flatbed scanner.

**Discrete multivariate analysis, 1981 (above)**

This is from a series of images produced by Barrow using photogram techniques on conventional photographic paper combined with spray lacquers and enamel paints. (The title refers to a method of statistical analysis.)

**Photographer:** Thomas Francis Barrow.

**Technical summary:** Gelatin silver photogram with automative lacquers and epoxy enamel.

## Photograms and shadowgrams

Making 'sun prints' with blueprint paper developed in water is one of the first experiences many of us have in photography. The process uses irons salts, rather than the more common silver, to create a blue image in UV-rich daylight from the shadows of objects laid on the paper. This process is exactly the same chemistry as the cyanotype (even the name recalls the blue image). Because of its associations with childhood and the early learning experience, many photographers dismiss direct image making using real-world objects, though are happy to experiment with contact printing from negative images.

Photograms are a form of lens-less image making. The process relies on the opacity of objects to prevent light from reaching photosensitive material, which then gives a strong negative image of their shape. Transparent objects and those with various densities give interesting partial exposure to the photographic paper. Light need not be directly from above but can be from the side – when reflections begin to expose the photosensitive material – or can even be moved during exposure. Some workers will wrap the photographic material around their chosen object and bathe it in light. Cliché verre is a related technique using images scratched or drawn on to glass or other transparent supports, from which a photogram is made.

The origins of the technique are associated with the recording of plant specimens; some of the finest older cyanotypes treated today as collector's art pieces were intended for scientific purposes. The names of Man Ray, László Moholy-Nagy and Christian Schad are closely associated with true art photograms using man-made objects. Man Ray called his photograms Rayograms and Schad called his Schadograms in wordplay on their names, though neither description has been used in connection with anything other than their own works. Man Ray was working within the Surrealist aesthetic, placing real-world objects in surprising juxtapositions to create new and imaginary meanings. Both he and Schad were better known as artists than photographers.

### Painting with light

It is possible to paint light into a photograph, using the photosensitive medium – film or digital – as a blank canvas on to which you can paint the light selectively. Obviously, the subject needs to be in a darkened room or outdoors at night so the camera shutter can be initially opened without recording an image. A discrete light source is then shone over the subject to build up the exposure over time. At the end of that time, the camera shutter is closed.

The technique can be used with either flash or with continuous light sources, ranging from simple pocket torches to sophisticated optic fibre 'light pens'. In fact, some studios are equipped with light brushes.

The easiest way to judge exposure with continuous light is to use the camera's aperture priority setting. Pre-focus on the subject using a continuous light source and then, in the dark, trigger the shutter. In total darkness, the camera will only close its shutter when the batteries run out. However, as you begin to paint light on to the scene, the light meter will 'add up' the light until it judges there to have been sufficient, then it closes the shutter. You may need to use exposure compensation to get accurate results with this method, as some camera meters have trouble exposing for bright subjects against black backgrounds and all will average to middle grey.

The technique with flash is to open the shutter and move around the subject firing off a manual flashgun to illuminate it. Older manual cameras that do not use battery power to keep the shutter open are best. Exposure is by experience; in very dark conditions a building can be flash illuminated in between 5 and 10 minutes with an aperture of f/5.6–f/8 using a flash with a guide number of 35–40 on full manual power. This is often referred to as 'open flash' technique.

Digital cameras can produce very noisy images with long exposures, unless they have some form of long-exposure noise reduction. A second image is recorded when the shutter is closed. This contains no pictorial information, only the 'noise' (pixels out of place) from the sensor itself. This signal is then subtracted from the real image as a method of reducing noise.

### White gladiolus (left)

Digital cameras provide an ideal way of checking exposure and what has been painted immediately after the exposure.

**Photographer:** Marion Luijten.

**Technical summary:** Canon 10D, Sigma 105mm macro lens. Camera on tripod. 6 sec at f/27, ISO 100, 'painted' during exposure with mini flashlight.

### Bank building, Rhyolyte (above)

The John S. Cook & Co. Bank in the 'ghost town' of Rhyolyte, Nevada, USA, photographed in the light of the full moon with ten additional flashes from a flashgun covered with red gel. Note the star tracks showing the length of the ambient exposure.

**Photographer:** Troy Paiva.

**Technical summary:** Manual 35mm camera from the 1960s, 19mm lens, ISO 160 tungsten balanced film. Lit by full moon, approximately an 8-minute exposure with the ten flash 'pops' done in a circle from inside the building.

# Conclusion ▷

Light is the photographic medium. Digital capture does not change the fundamentals. Light still travels in straight lines, casts shadows and falls away in inverse proportion to the square of the distance, whether it is caught on colour film, black-and-white film or a digital sensor.

Studio lighting can seem overwhelmingly complex to those starting out in photography. It has evolved its own language and gadgetry, while the apparent complexity of some lighting setups seems certain to discourage the beginner. Hopefully, this book has demystified the jargon and shown that, however complex the final setup, it is based on simple first principles. The key is choosing where to place the main light and the type of light that it is to be; the rest is trimming. With the sun, you need patience and the co-operation of the weather gods.

The type of light you wish to use will be dependent on the subject to be photographed – that is as true of the variety of faces in portraiture, as portraiture itself is different from still-life or product photography. Assessing the subject carefully in terms of the formal elements of composition and deciding how to exaggerate or hide certain features will dictate how to approach the lighting.

Do not go away with the impression that good lighting is the same as complex lighting. Some of the finest portraits are taken with little more than window light and a reflector, the image created by the 'seeing eye' of the photographer. Mastering a simple 'one lamp and reflector' setup can be the basis of a career.

That is not to underestimate the skills of the studio photographer who uses complex controlled lighting with great style to bring out every last detail of the subject. How you approach your images will depend on how much you are drawn to the craft of lighting. What is more important is to develop sensitivity to the subject matter and to keep the lighting true to that. Always record and understand what you do.

The necessary technical skill is having an understanding of subject brightness range and realising that having and knowing how to use a good incident light meter is more important than the choice of camera. Remember the limits of the medium and work within them. Beginners fret about their choice of equipment; those with more experience talk about technique, but it is the expert who worries about the light.

# Contacts

**Stéphane Bourson**
www.sbourson.com

**Adam Burton**
www.adam-burton.co.uk

**Jorge Coimbra**
www.jorgecoimbra.home.sapo.pt

**Kit Courter**
www.home.earthlink.net/
~lunarlightphoto

**Colin Demaine**
www.colindemaine.com

**Rod Edwards**
www.rodedwards.co.uk

**Branislav Fabijanic**
bfabijanich@yahoo.com

**Karl Fakhreddine**
www.tangerineglow.com

**Andy Flowerday**
fleurjour@members.v21.co.uk

**Alain Gauvin**
www.alaingauvin.com

**Anton Heiberg**
www.angelfire.com/art/heiberg

**Sam Henderson**
samfotos@hotmail.com

**Eric Kellerman**
www.erickellermanphotography.com

**Brad Kim**
www.photo.net/photodb/
user?user_id=496411

**Marion Luijten**
www.coloursofnature.nl

**Phil McCann**
www.philmccann.com

**Doug Mauck**
http://members4.clubphoto.com/
doug220445

**Jean-Sébastien Monzani**
www.jsmonzani.com

**Denis Olivier**
www.denisolivier.com

**Packshot Factory Limited**
www.packshotfactory.co.uk

**Troy Paiva**
www.troypaiva.com

**Stephen Payne**
www.stevepaynephotography.co.uk

**David Präkel**
**PhotoWorkshops Partnership**
www.photopartners.co.uk
david@photopartners.co.uk

**Justin Quinnell**
www.pinholephotography.org

**Bjørn Rannestad**
www.rannestadphotos.com

**Scott Ritenour**
www.saturnlounge.com/sr

**Dale Sanders**
hyrail@sbcglobal.net

**Jean Schweitzer**
www.cliclac.dk

**Lisa Smith**
www.lisasmithstudios.com

**Juergen Specht**
www.juergenspecht.com

**Becca Spence**
www.becca-spence.co.uk

**Ian Taylor**
ded@ntlworld.com

**Michael Trevillion**
**Trevillion Images**
www.trevillion.com

**Wilson Tsoi**
www.photo.net/photos/wilsontsoi

**Frank Wartenberg**
www.frank-wartenberg.com

**Jeremy Webb**
www.pixelsoup.biz

**Ilona Wellmann**
**Trevillion Images**
www.IlonaWellmann.meinatelier.de
www.trevillion.com

**Adrian Wilson**
www.mcfade.com

**Gill Wilson, ARPS**
gillwilson@him2004.plus.com

**asymmetric generator**
power supply that can feed two or more flash heads of different power outputs.

**axial light**
light from a source as close as possible to the optical axis of the camera lens.

**back light**
light from behind the subject towards the camera, creates rim of light around subject but can be difficult to meter and can produce lens flare.

**base light**
light from underneath.

**battery pack**
power supply for flash heads that is charged by mains electricity but works independently and can be used in the field.

**boom**
long counterbalanced arm to support lamp or flash head over subject in the studio.

**bounce**
(verb) to reflect light back; (noun) a reflective flat. See flat.

**bracketing**
intentional over- and underexposure from the indicated exposure, usually in whole or half stops.

**butterfly lighting/butterfly shadow**
lighting from near to and above the camera that casts a butterfly-shaped shadow beneath the nose of the subject on their top lip.

**catchlight**
bright reflection in the eyes of the subject in a portrait.

**colour balance**
truthfulness of colours across the spectrum.

**colour balancing filters**
amber and blue filters used when making colour temperature changes, sometimes referred to as warming or cooling filters respectively or light balancing filters.

**colour cast**
unwanted, overall colour change in an image.

**colour conversion filters**
deep blue and orange filters used to achieve significant shifts in colour temperature, to correct white balance when using film and lighting of a different target colour temperature.

**colour temperature**
measure of 'whiteness' of light, measured in kelvin. See white balance.

**continuous light**
any light source that shines without break or interruption.

**cookie**
metal perforated disc with pattern or symbol used in a spotlight to project this on to subject or background. See gobo.

**cutter**
matt black painted flat that absorbs light.

**daylight**
average summer sunlight as measured at noon in Washington, DC, corresponds to a colour temperature of 5500k.

**depth-of-field**
apparent sharpness in front of and behind the exact point of focus; varies with format, aperture and focusing distance.

**desaturate/saturate**
decrease/increase the strength of all colours.

**diffuser**
piece of cloth, netting or translucent material used over light source to spread light over a wider area to soften shadows.

**direct/reflected reading**
light meter reading of light reflected by the subject as opposed to an incident reading.

**effects light**
a small light – neither the key light nor fill light – used to illuminate a small portion of the subject, often a mini spotlight.

**eggcrates**
interlocking cloth grids for use on softboxes, work to pool the light as a honeycomb does on a bare bulb.

**EV (Exposure Value) number**
single number representing a range of equivalent combinations of aperture and shutter speed. EV unit is one stop.

**fill light**
light from a reflector of a separate lamp or flash head used to illuminate the shadows cast by key (main) light and so reduce the lighting ratio.

**film speed**
measure of photographic film's sensitivity to light. See ISO.

**filter**
glass or plastics device that modifies light passing through the camera lens. Computer software module that applies an image effect.

**filter factor**
filters cut out certain wavelengths of light, reducing the amount of light that reaches the film or sensor; for a correct exposure an allowance must be made. A filter that cuts out half the light will have a factor of x2 and 1 stop must be added to the exposure indicated by an incident light meter reading.

**flag**
piece of opaque material often mounted on a boom or arm used to block non-image forming light and reduce lens flare.

**flash head**
usually a combined flash tube, modelling light and cooling fan that takes its power from a separate battery pack or generator in contrast to an integrated monobloc/monolight.

**flash synchronisation**
timing brief burst of light from flashgun to appear between the opening and closing of the camera shutter.

**flat**
large sheet of expanded polystyrene or foam core board (lightweight) used to reflect light or cast shadows.

**floodlight**
lamp used to illuminate a wide area as opposed to spotlight (use now more common in theatre and film).

**focal plane shutter**
camera shutter that operates close to the film/sensor in the plane of focus of the lens. Comprises adjustable slit between two 'curtains' that travels to expose film/sensor to light. To synchronise properly with flash, slit must be wide enough to expose whole film/sensor.

**f-stop**
diameter of the lens opening represented as a fraction of the focal length. The bigger the f number, the smaller the opening.

**generator**
power unit for two or more flash heads; pack and heads (USA).

**gobo**
(from contracted 'go between') piece of perforated opaque material (card, metal, foamboard etc.) used between light source and background to cast pattern in light.

**graduated filter (grad)**
partly toned resin or plastics filter with slightly more than half of the filter clear. Used to darken skies or control contrast.

**grey card**
standard piece of card that reflects 18 percent of the light falling on it to provide an exact mid-tone light reading.

**guide number**
a number used to describe the maximum coverage distance of a flash unit for a given lens aperture and film speed/sensitivity.

**hair light**
lamp or flash positioned to illuminate subject's hair, often used behind subject to light up a rim of hair separating subject from background.

**HID lighting**
generic terms for High Intensity Discharge lighting including HMI and HQI lamps.

**HMI lamp (metal halide)**
type of HID lamp; rapidly pulsed light giving effectively continuous output running at daylight colour temperature (5600K), (from hydrargyrum (mercury) medium-arc iodide).

**hot shoe**
camera accessory shoe with electrical (hot) contacts for triggering flash when shutter is released.

**HQI lamp (metal iodide)**
type of HID lamp (from hydrargyrum (mercury) quartz iodide).

**incident reading**
light meter reading of light falling on subject as opposed to light that is reflected from it.

**iris**
metal blades that create variable aperture in lens.

**ISO**
International Organization for Standardization – body that sets standard for film speeds and matching digital sensitivity (ISO number).

**kelvin**
unit of measurement for colour temperature – not degrees kelvin.

**key light**
main light source.

**leaf shutter**
shutter mechanism usually found in between lens elements; because of nature of its operation, flash synchronisation can occur at any shutter speed. Usually found in lenses for medium and large format cameras.

**light meter/exposure meter**
measures intensity of light for photography, giving value as a combination of shutter speed and aperture or a single Exposure Value (EV) number for a given film speed or sensitivity.

**light shaper**
anything that modifies the light from a lamp or head.

**lighting ratio**
comparison of two light intensities sometimes expressed in stops. May be described as the key-to-fill ratio; the combined intensity of the key and fill lights compared to the key light alone.

**mired**
from micro reciprocal degrees – pronounced 'my-red'. One million divided by colour temperature; commonly used unit when converting from one colour temperature to another using filters.

**modelling lamp**
continuous light lamp usually set at the centre of the flash tube in a studio flash head to show effect of the light from flash itself, does not contribute to exposure.

**monobloc**
studio flash unit with independent built-in power source. Monolight (USA).

**multiple flash**
build up exposure with series of flashes.

**ND filter**
neutral density filter that reduces light intensity equally across spectrum.

**northlight**
area light or softbox imitating the look of a north-facing window (lit by indirect daylight) (Northern Hemisphere only).

**overexposure**
images created with too much light, having no shadows or dark tones. See underexposure.

**photoflood**
tungsten filament (incandescent) lamp running at higher voltage than normal (overrun) which means short life. Colour temperature either 3200K or 3400K.

**polarizer/polarizing filter**
used over lens to control reflections from non-metallic surfaces and to darken skies at 90 degrees to the sun.

**reflector**
object that reflects much of the light that falls on it. Usually white, silvered or gold coloured.

**rim light**
light that comes round the edge of a subject from a source behind or to the side.

**skylight**
light of blue quality reflected from atmosphere, mixed with direct sunlight and reflected light from clouds gives daylight.

**slave flash**
independently powered flash gun that is triggered by flash of main unit, often of lower power and used as effects light.

**soft light**
diffuse light that gives few shadows and appears to come from a large area relative to the subject.

**softbox**
box or frame covered with translucent (light diffusing) material used over flash head to create a soft light, available in various sizes.

**spill**
extra light that 'overshoots' the subject. It can be used on a background or reflected back on to the subject but may produce lens flare and needs to be controlled with barn doors on the lamp or flash head, flags or gobos.

**spot (mini spot and zoom spot)**
spotlight; small spotlight; spotlight with adjustable reflector.

**spot meter**
light meter that takes a reflected light reading from a very small area of the subject (1–4° acceptance angle). Camera spot meter functions are commonly not as selective unless telephoto lens used.

**subject brightness range**
range of light to dark presented to the camera by the subject is a combination of the subject contrast and the lighting ratio.

**subject contrast**
inherent contrast in the subject when evenly lit.

**sun compass**
magnetic compass that shows where the sun will rise and set at any time of year.

**sun finder charts**
published charts that give the direction and elevation of the sun at any time of day throughout the year – especially useful for architectural photography.

**symmetrical generator**
power unit for two or more flash heads that will only deliver similar powers to each head.

**sync**
to time the moment a flash is fired to coincide with the correct opening of the camera shutter for a proper exposure.

**tri-flector**
folding reflector with three surfaces much used in portraiture.

**TTL (Through The Lens)**
reflected light meter in cameras that measures light through the taking lens.

**tungsten**
incandescent (glowing) electric light bulb with filament of tungsten metal. Hot and inefficient, but unlike flash its effect can be seen and judged; used as modelling lamps in flash heads.

**underexposure**
images created with too little light, no highlights or light tones. See overexposure.

**watt**
SI (International System of Units) unit of power; the rate at which work is done. One joule of work per second of time. Watt rating of tungsten lamp indicates light output.

**white balance**
adjusting for the colour temperature of the illuminating light, so white and neutral colours appear truly neutral and do not have a colour cast.

**white light**
equal blend of all colours in visible spectrum.

I would like to acknowledge a debt long owed to Mrs 'Mac' of H N Brookes Ltd. Doncaster (Cameras) for her enthusiasm, humour and support.

For this book: many thanks to John Heffernan of Meggaflash Technologies for supplying sample flashbulbs; to Geraldine Joffre of HDRSoft for help with tone mapping software; to Sandra Myers for the loan of the sun compass and conversations about sunrise, sunsets and lighting in the landscape.

Thank you to Cumbria Institute of the Arts technical staff Tony Oliver, Roger Lee, (Resource Manager, Photography) and especially Gill Wilson (Senior Technical Demonstrator) for her help in the studio. Particular thanks are due to photography students Bianca Collie, who modelled for the portrait lighting setups, and Kate Boswell who capably assisted in the studio.

A general thank you both to my colleagues and those photographers who took time to share their techniq... owe a debt of gratitude to my wife A... read my manuscript.

A final thank you to Brian Morris at A... project wouldn't have seen the light...

**CREDITS**

Page 3: Image courtesy of Getty Images/Hulton Archive.
Page 17: Gernsheim Collection, Harry Ransom Humanities Research Center, The University of Texas at Austin.
Page 52: (Ilona Wellmann) Trevillion Images.
Pages 54 and 59: From the exhibition: New Views: Old Landscapes, curated by Dr Mark Heywood.
Page 62: Image courtesy of Sunbounce.
Pages 88 and 89: Images courtesy of Photon Beard images and ARRI.
Page 115: Image courtesy of Bowens.
Page 132: Self Portrait, c.1660–63 (oil on canvas) by Rembrandt Harmensz van Rijn (1606–9) © Prado, Madrid, Spain/The Bridgeman Art Library.
Page 136: Image courtesy of Steve Payne Photography.
Page 136: Blu-Tack® is a registered trade mark of Bostik.
Page 152: From a self-instigated photographic project – The Mortensen Project.
Page 165: Image courtesy of Getty Images/Time Life Pictures.
Page 168: Collection of the Museum of Fine Arts, New Mexico, Gift of Patti and Frank Kolodny, 1990.

All reasonable attempts have been made to secure permissions and trace and correctly credit the copyright holder of the images produced. However, if any are incorrect or have been inadvertently omitted, the publisher will endeavour to incorporate amendments in future editions.